AMERICAN TREASURES
THE BRANDYWINE
RIVER MUSEUM
OF ART

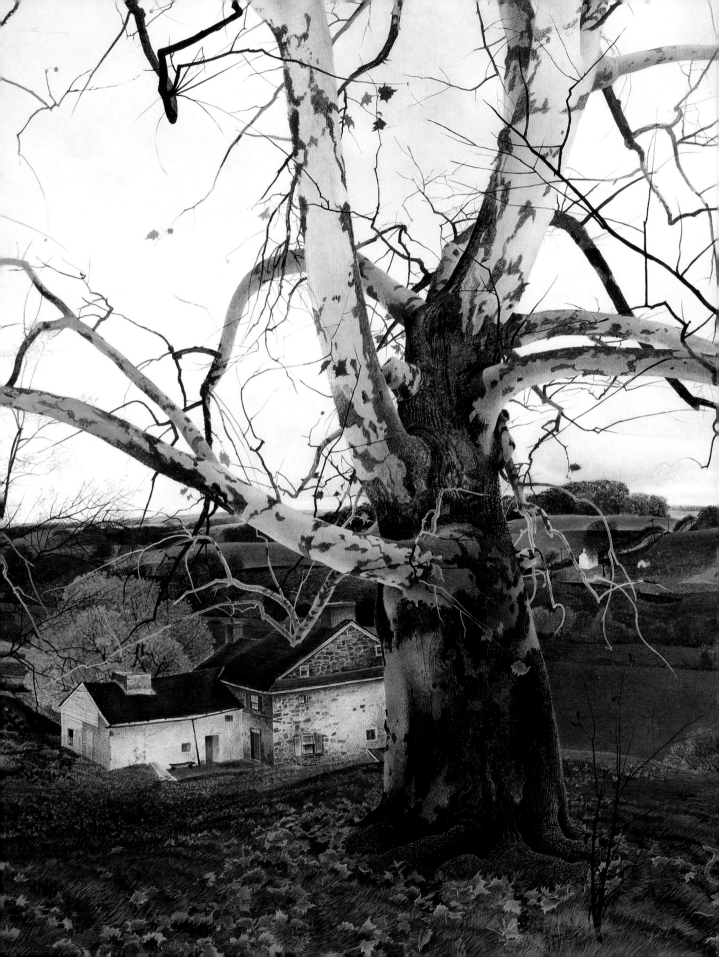

AMERICAN TREASURES
THE BRANDYWINE RIVER MUSEUM OF ART

FOREWORD BY
Thomas Padon

ESSAY BY
Christine B. Podmaniczky

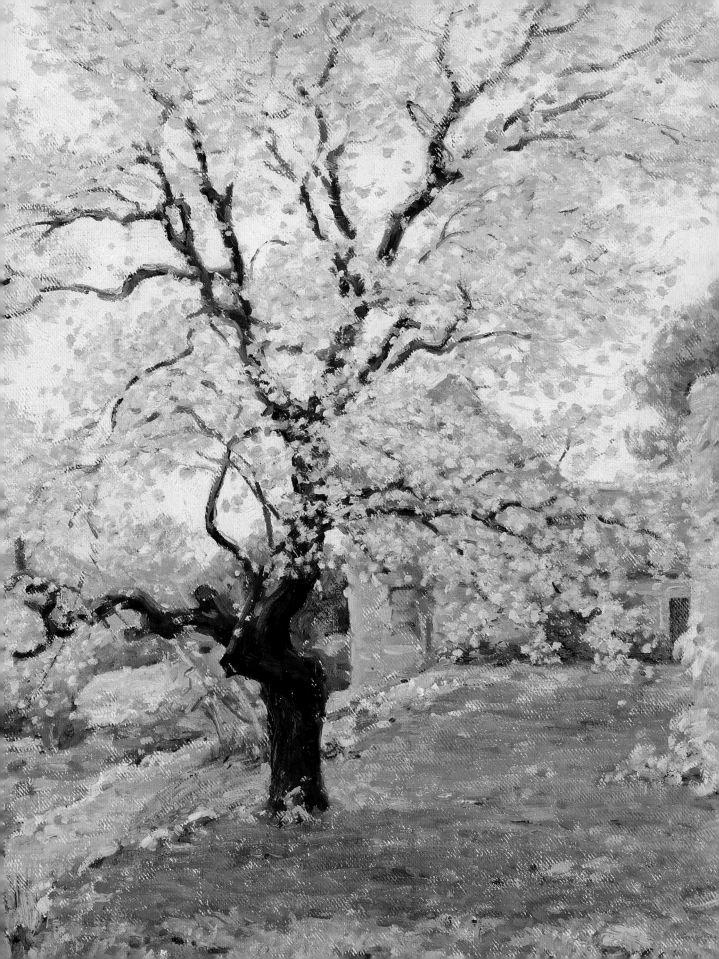

TABLE OF CONTENTS

PAGE 4
William Chadwick (1879–1962)
The Cherry Tree (The Cherry Blossoms), n.d.
Oil on canvas, 24 x 20"
Richard M. Scaife Bequest, 2015

BELOW
Museum entrance

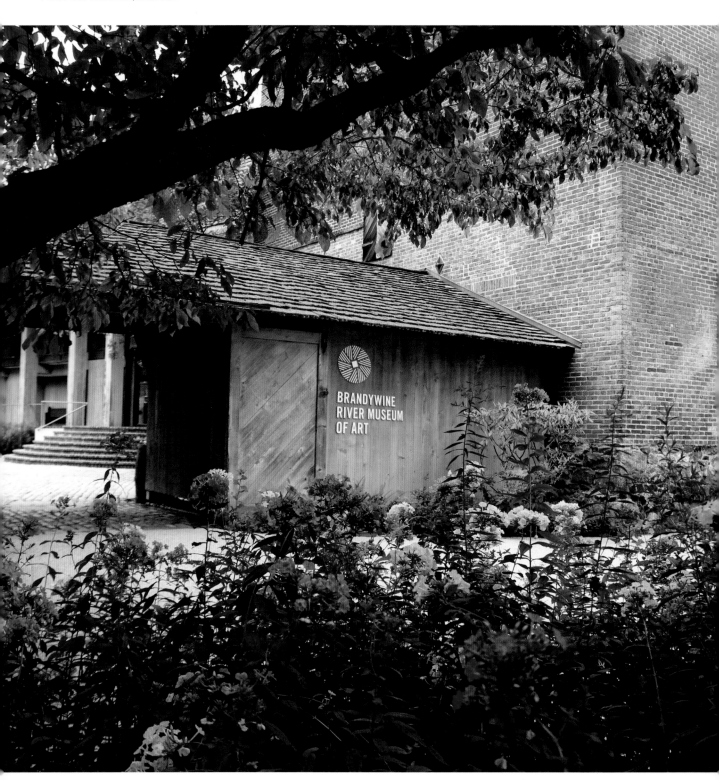

FOREWORD

The Brandywine River Museum of Art provides an extraordinarily immersive experience of American art that is unmatched in the United States. In the mid-nineteenth century, the Brandywine Valley became known to artists as a place celebrated for its beauty and history. Such figures as William Trost Richards, Howard Pyle, and Horace Pippin would, at turns, settle in the valley's environs. Founded in 1971, the Museum reflects the artistic heritage of the region. The collection, now comprising more than 4,000 works of art, is particularly extensive in the areas of landscape, still-life, and portrait painting, and it also includes works by Gilbert Stuart, John Kensett, Albert Bierstadt, Martin Johnson Heade, William Michael Harnett, J. Alden Weir, Guy Pène du Bois, and other notable American painters.

It was N. C. Wyeth's move to Chadds Ford in 1908, however, that began what is today the most remarkable aspect of the Brandywine River Museum of Art. A larger-than-life figure and the most celebrated illustrator of his day, N. C. Wyeth was the first of three generations of artists that later included his son Andrew and Andrew's son Jamie. Today, the Museum is the largest repository of works by the Wyeth family, many of which were created in Chadds Ford. It also owns and makes accessible to the public three extraordinary sites that are all National Historic Landmarks: the N. C. Wyeth House and Studio, the Andrew Wyeth Studio, and Kuerner Farm. Visitors have the opportunity to view paintings by the Wyeths in the Museum's galleries, and then walk, literally, in the footsteps of the artists by traversing some of the sites they depicted and touring the studios in which many of their works were created. The beauty of the surrounding grounds speaks to the activities of the Brandywine Conservancy—the other program of the Brandywine Conservancy & Museum of Art. The Conservancy, as one of the leading land trusts in the

country, protects over 62,000 acres in Pennsylvania and Delaware, including areas in and around Chadds Ford that have proven so inspirational to artists for more than a century. Here the visitor can find a remarkable intersection of art and nature.

In these pages, Christine B. Podmaniczky, curator of N. C. Wyeth Collections and Historic Properties, provides a discerning introduction to the cultural and historic richness of the Museum. She illuminates the story of the founding of the institution, traces the evolution of its collection, and recognizes generous individuals most responsible for its growth. These pages feature a sample of the Museum's most treasured works and offer a fine introduction to the history, collection, and setting that give the Brandywine River Museum of Art true distinction. I invite you to spend some time here: discover and enjoy the Brandywine experience.

THOMAS PADON

THE JAMES H. DUFF DIRECTOR
BRANDYWINE RIVER MUSEUM OF ART

Howard Pyle (1853–1911)
The Nation Makers, 1903
Oil on canvas, 40 $\frac{1}{4}$ x 26"
Purchased through a grant from
the Mabel Pew Myrin Trust, 1984

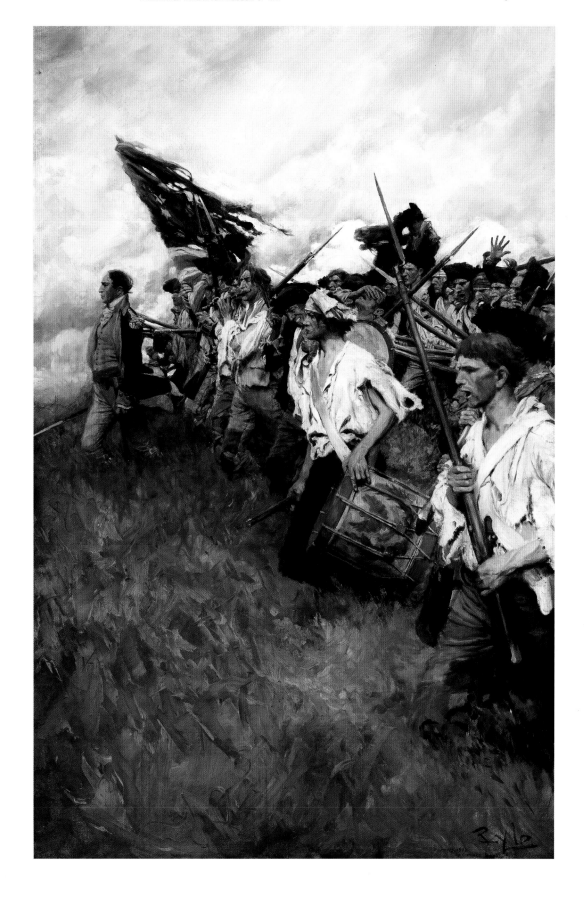

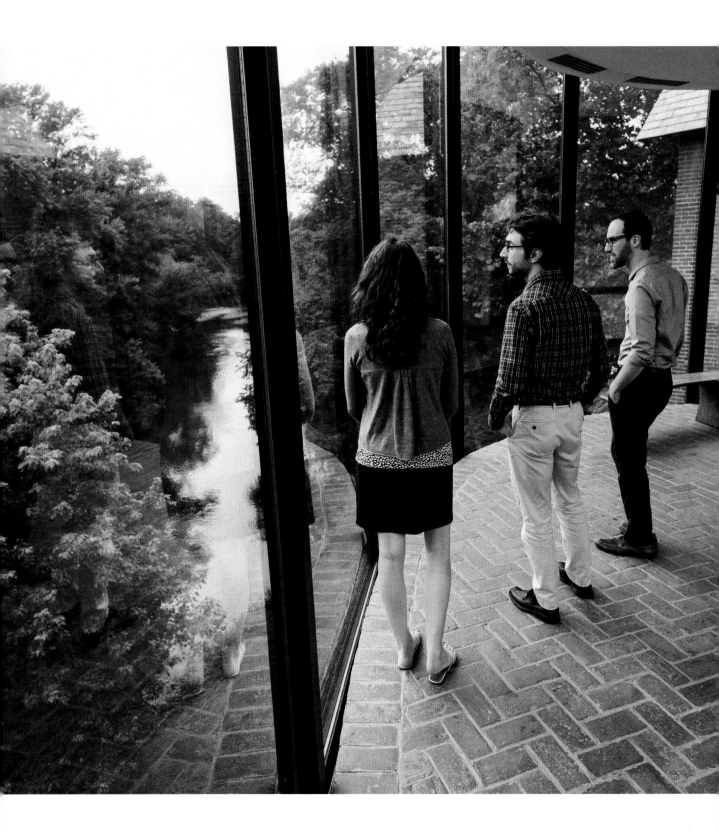

INTRODUCTION

When entering the Brandywine River Museum of Art, visitors are drawn through the atrium to a wall of glass that overlooks a bucolic river. The vista, so dramatically transformed throughout the year—lushly green in spring and summer, alight with vibrant golds and yellows in autumn, and starkly beautiful in the snows of winter—immediately conveys the foundational relationship between art and nature that constitutes the Museum's defining character. As visitors move through the galleries, always returning to the atrium and the river view, they find their engagement with the landscape has deepened, for much of the art that can be enjoyed in the Museum was created by artists who settled or worked in this region, attracted by the pastoral beauty of the Brandywine Valley. Since the nineteenth century, artists working in a rich array of styles and mediums have responded to the inspirational imperative of the fertile, gently rolling countryside, its rich history, and its lively culture. The Museum collections, its architecture, and its natural setting all reflect, in large measure, this extraordinary confluence of the landscape and distinct cultural identity of southeastern Pennsylvania.

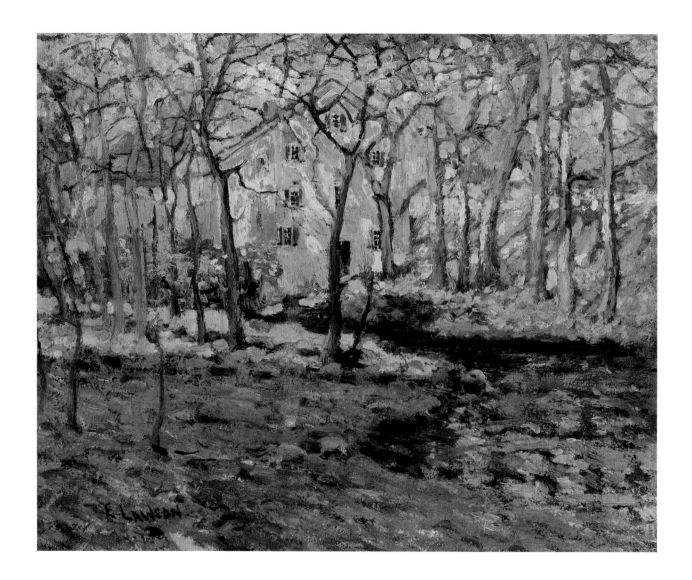

Ernest Lawson (1873–1939)
An Old Saw Mill, n.d.
Oil on canvas, 16 $^1/_4$ x 20 $^1/_4$"
Richard M. Scaife Bequest, 2015

John McCoy (1910–1987)
Brandywine at Twin Bridges, 1953
Tempera on panel, 22 $^7/_8$ x 30"
Gift of Alleta Laird Downs
in memory of W. Brooke
and Marjorie H. Stabler, 1992

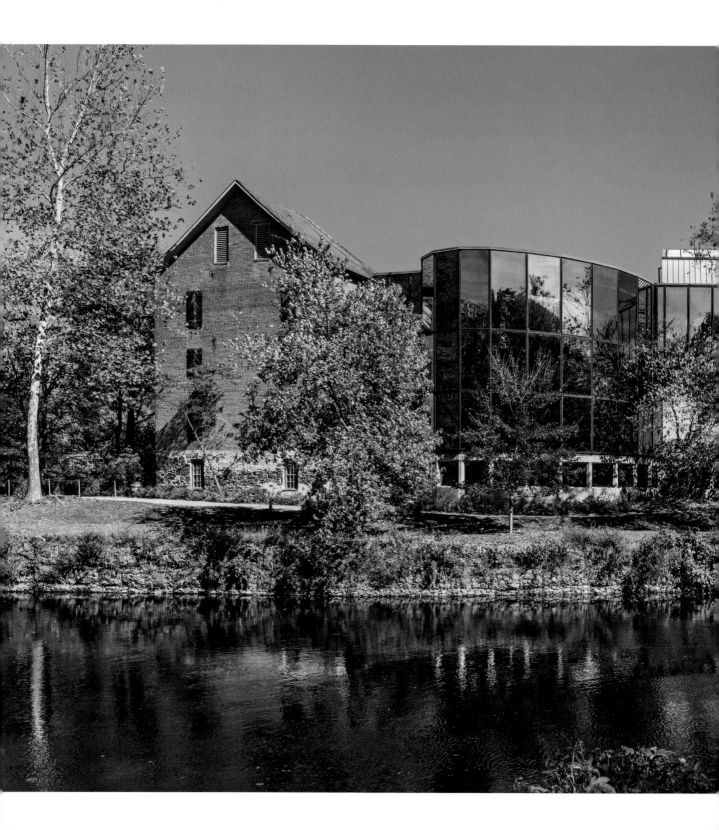

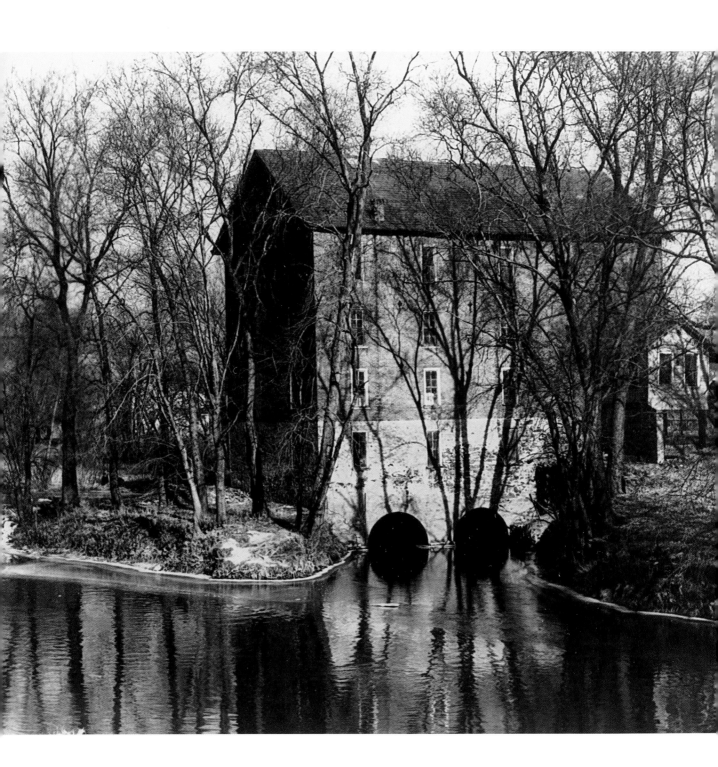

HISTORY OF THE MUSEUM

The Brandywine River Museum of Art was conceived as part of a farsighted partnership. Its parent organization, the Brandywine Conservancy & Museum of Art, was begun by a group of concerned residents who incorporated in 1967 with the ambitious goal of preserving the cultural and natural assets of the Brandywine Valley. The Conservancy's founders, Francis I. du Pont, William Prickett, and George A. "Frolic" Weymouth, were joined by other prominent members of the community, including Henry Francis du Pont, Harry G. Haskell Jr., Anna B. McCoy (then the wife of George Weymouth), and Phyllis du Pont Mills (who would later marry Jamie Wyeth). With encouragement from Chadds Ford residents Andrew and Betsy Wyeth, the group formed an organization dedicated to countering the effects of rapidly encroaching industrial development on the area's natural resources. Simultaneously, the members envisioned the establishment of a museum, one devoted to American art with a particular strength in art of the Brandywine region—landscape, still-life, and trompe-l'œil painting; illustration; and, notably, work created by the artists in three generations of the Wyeth family. Fifty years later, this singular association based on the preservation of art and nature has flourished. The Brandywine Conservancy safeguards more than 62,000 acres of scenic and natural resources, farmland, and historic properties throughout Pennsylvania and northern Delaware. Concurrently, the Brandywine River Museum of Art has seen tremendous growth, forming a distinguished permanent collection that has grown to include nearly 4,500 paintings, drawings, prints, and sculptures from the nineteenth to the early twenty-first centuries.

Hoffman's Mill, 1864,
undated photograph
Walter and Leonore
Annenberg Research Center,
Brandywine River Museum
of Art

The Museum opened its doors in 1971 and is housed in a mid-nineteenth-century gristmill situated on the riverbank in the historic village of Chadds Ford. In an early example of adaptive reuse, the mill building was transformed into galleries by the Baltimore-based firm GWWO, Inc./Architects, who retained the mill's wooden beams as key architectural elements. The original—and now iconic—brick building continues to present visitors with their initial view of the Museum and conveys an even more forceful impression through the dramatic contrast with the sleek glass and steel additions of 1984 and 2004.

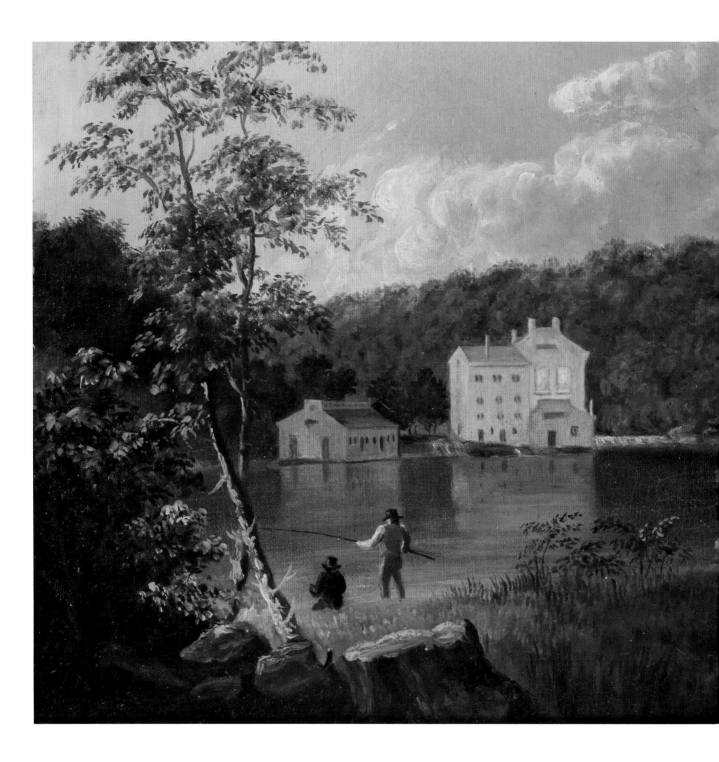

Thomas Doughty (1793–1856)
Gilpin's Mill on the Brandywine, 1830
Oil on canvas, 7 $^1/_4$ x 11"
Museum purchase, 1986

Also designed by GWWO, these additions incorporated galleries and the spiraling, three-story atrium that offers visitors panoramic views of the river. Clad in mirrored glass, the atrium and later additions respect the lyrical beauty of the Museum's setting by reflecting surrounding trees and the ever-changing cloudscape.

The Museum's immediate campus encompasses approximately fifteen acres. Wildflower and demonstration gardens–featuring plants, shrubs, and trees native to the region–surround the main buildings and reinforce the Brandywine Conservancy's commitment to environmental sustainability and stewardship. Since 2015, these grounds have also provided a dramatic setting for temporary installations commissioned by the Museum from artists such as James Welling and Dylan Gauthier, whose site-specific works speak to the intersection of art and nature in the contemporary world.

OPPOSITE
A millstone evokes the former
gristmill's past.

BELOW
The Andrew Wyeth Studio

NEXT PAGES
James Welling (b. 1951)
Gradient (River Walk), 2015
Dye sublimation print on aluminum, 84 x 16"
Gift of the artist, 2016

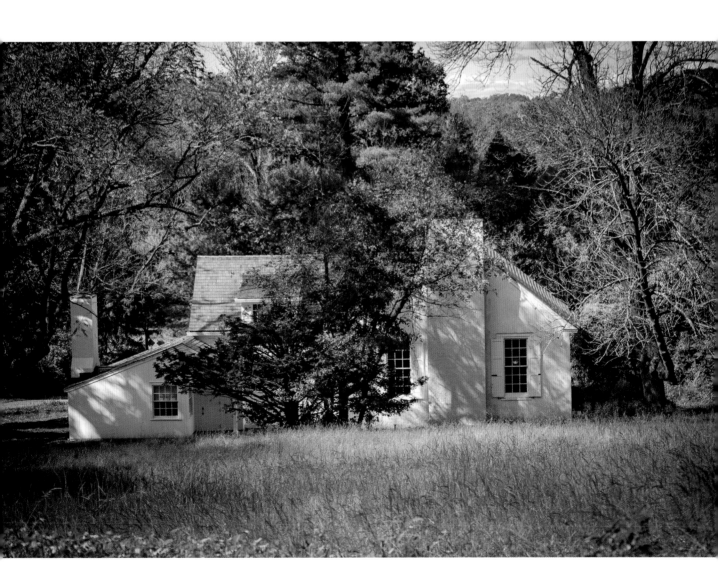

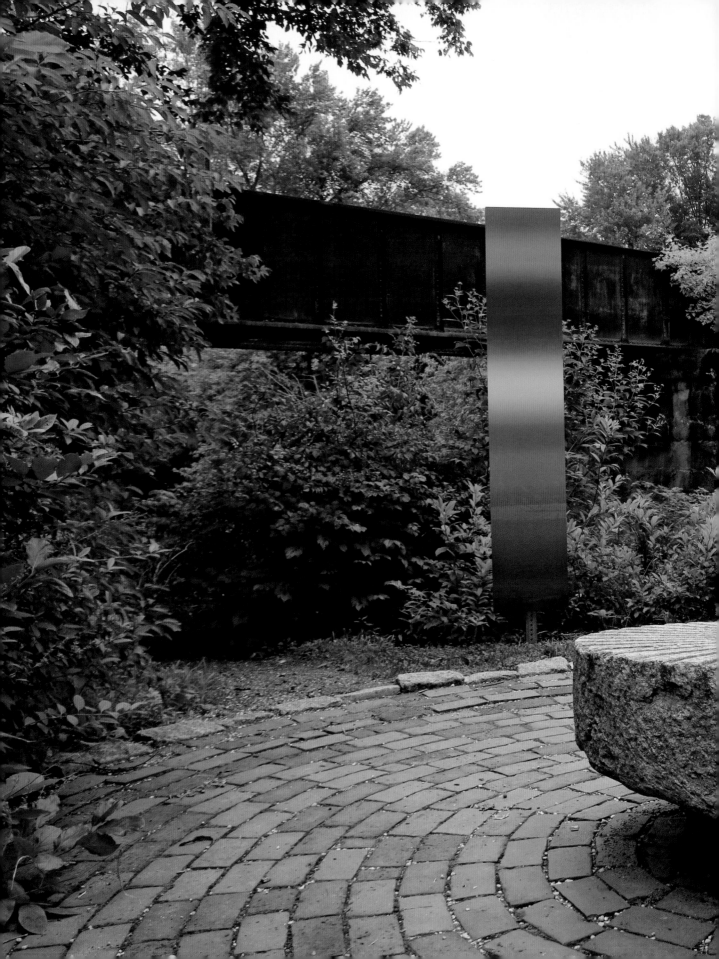

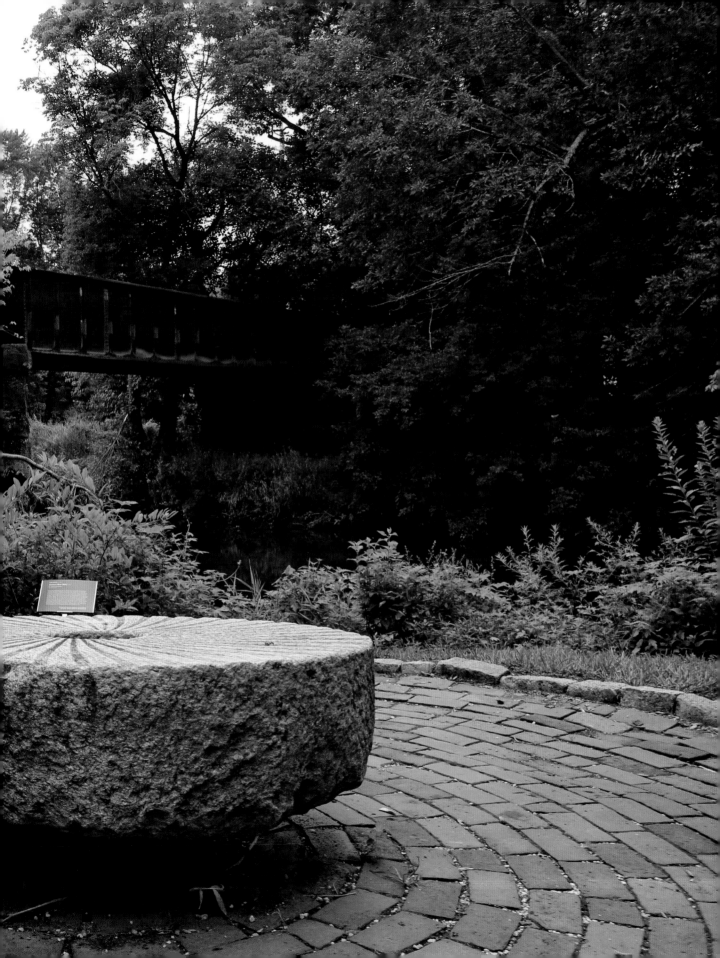

HISTORY OF THE COLLECTION

The collection's growth over almost a half century marks the passion and generosity of many key donors. Andrew and Betsy Wyeth were among the earliest contributors, even before the Museum officially opened. The Wyeths gave nine paintings by artists whose names are firmly associated with the Brandywine Valley, including N. C. Wyeth and other Wyeth family members, and the Museum's first painting by George Cope. The Wyeths' generosity continued: acquisition of Horace Pippin's *Saying Prayers*, Frank Schoonover's illustration for Jack London's "White Fang" (page 131), and Jamie Wyeth's *Portrait of Pig* (page 121), all among the Museum's best-known works, were made possible by their sustained commitment to the Brandywine. Harry G. Haskell Jr., one of the Brandywine Conservancy's founders, and Mimi Haskell were also among the early supporters who helped build the emerging collection by giving significant works, such as Andrew Wyeth's *James Loper* and *Roasted Chestnuts* (page 29).

In 1980, Amanda K. Berls and Ruth A. Yerion donated more than forty paintings from their personal collections, making pivotal gifts that considerably expanded the scope of the Museum's holdings. With work by artists such as Jefferson David Chalfant, Asher B. Durand, John Haberle, William Michael Harnett, Mary Blood Mellen, Maxfield Parrish, and N. C. Wyeth, the Berls and Yerion gifts enriched existing spheres of interest in painting—landscape, still life, and trompe l'œil, for example—with key pieces that reveal defining movements, styles, and genres in the currents of American art history. A gift in 1982 and a subsequent one in 2003 by Jane Collette Wilcox totaling more than 350 works by more than 190 artists greatly augmented the Museum's collection of American illustration, thus making it one of the most comprehensive in the country. The Brandywine's already extensive holdings of paintings and drawings by Howard Pyle were significantly enhanced in 2007 by a major gift from Howard Pyle Brokaw, the artist's grandson. Brokaw's vital contribution included more than 125 paintings, as well as invaluable related reference material. Holdings by

George A. Weymouth
(1936–2016)
August, 1974
Tempera on panel,
49 1/4 x 49"
Gift of George A. Weymouth and his son in memory of the artist's father and mother, 1989

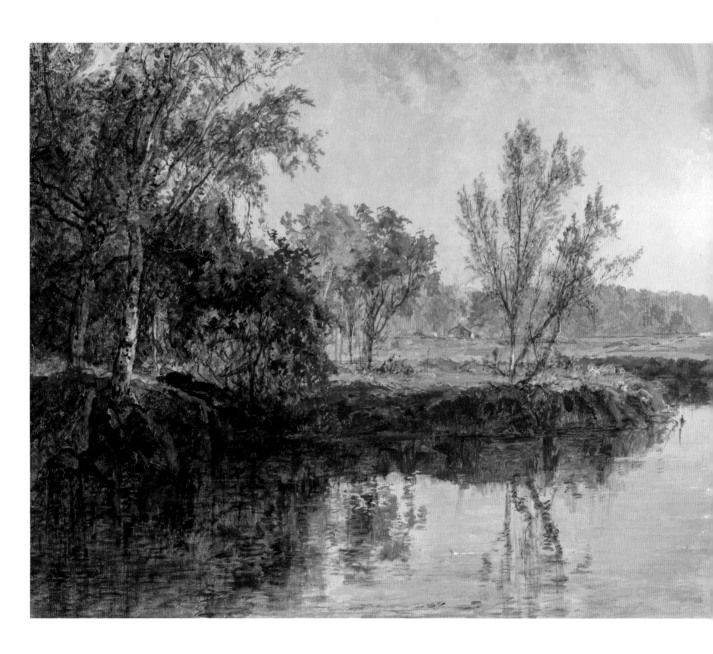

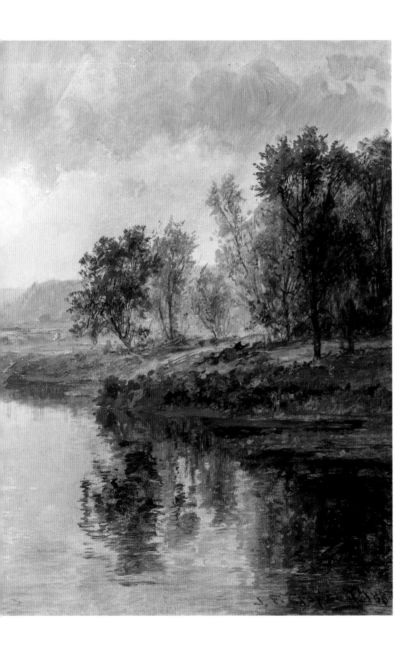

Jasper Cropsey (1823-1900)
Autumn on the Brandywine River, 1887
Oil on canvas, 10 $^7/_8$ x 20 $^3/_4$"
Museum purchase, 1981

N. C. Wyeth, the largest of any museum, were made possible by contributions from Mrs. Russell G. Colt, S. Hallock du Pont, and Carolyn Wyeth. Carolyn Wyeth's bequest contained more than 80 paintings and 150 drawings dating from all periods of her father's career and also included relevant archival material from his studio.

The range of American portraits in the collection was greatly expanded in 2005 with a gift of paintings of members of the Hare family by Henry Inman, Benjamin West, Thomas Sully, and Gilbert Stuart. This generous donation was made by Hope and Charles Hare. In 2014, Richard M. Scaife's bequest of nineteenth- and early twentieth-century paintings marked a significant extension of the Brandywine's holdings in American landscape and still life. Works by artists new to the Brandywine—Martin Johnson Heade, John Kensett, Ernest Lawson, Willard Metcalf, Theodore Robinson, Lilly Martin Spencer, and J. Alden Weir—and a significant painting by Thomas Moran were included in this major acquisition. With fine examples of American Impressionism and landscape traditions from across the United States, the Scaife bequest not only increased the scope of the Brandywine's existing holdings, but also tied them to a broader context of American art.

Over the years, a primary resource for acquisition has been the Museum Volunteers' Purchase Fund, supported by various annual events undertaken by an extraordinarily dedicated and talented group of individuals from the tri-state area, who graciously donate their time and skills. Since 1971, volunteers have organized a well-regarded antiques show that features vendors from across the country. The volunteers also use natural materials to create delightful, whimsical ornaments known as "Critters," the sale of which has become a Brandywine holiday tradition. Proceeds from these endeavors and other projects have enabled the Museum to purchase noteworthy paintings by many artists, including Horace Pippin, Howard Pyle, Severin Roesen, Andrew Wyeth, and Jamie Wyeth.

The Brandywine's esteemed Heritage Collection highlights the work of artists who have lived in or visited the Brandywine or greater Pennsylvania regions and traces the growth of American landscape painting. The Museum holds examples of work by early practitioners such as Thomas Birch and Thomas Doughty that portends the dominance of the landscape tradition in the nineteenth century. Artists best known as Hudson River school painters—Asher B. Durand and John Kensett—brought their romantic sensibilities and luminous style to the region in the middle of the 1800s. Jasper Cropsey's brilliantly colored

Andrew Wyeth
(1917–2009)
Roasted Chestnuts, 1956
Tempera on panel, 48 x 33"
Gift of Mimi Haskell, 1971

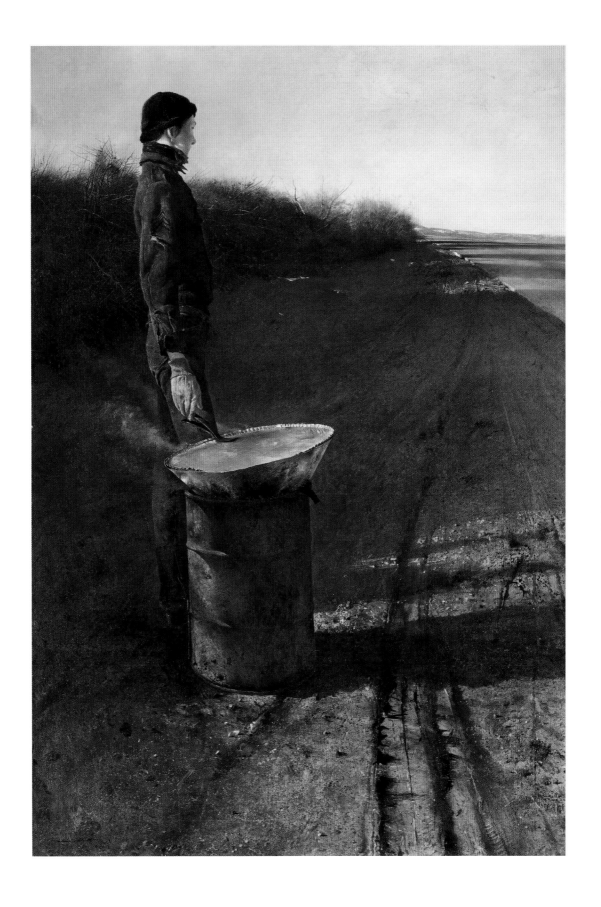

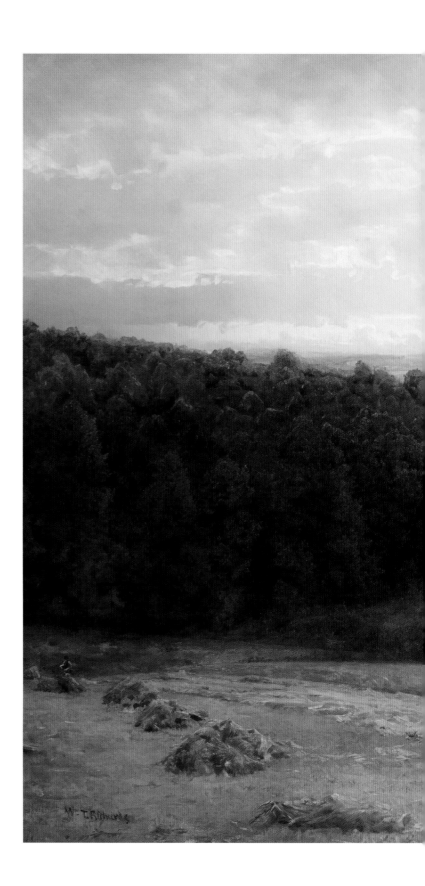

William T. Richards (1833–1905)
The Valley of the Brandywine,
Chester County (September), 1886–1887
Oil on canvas, 39 $^3/_4$ x 55 $^1/_8$"
Purchased through a grant from
the Pew Memorial Trust, 1986

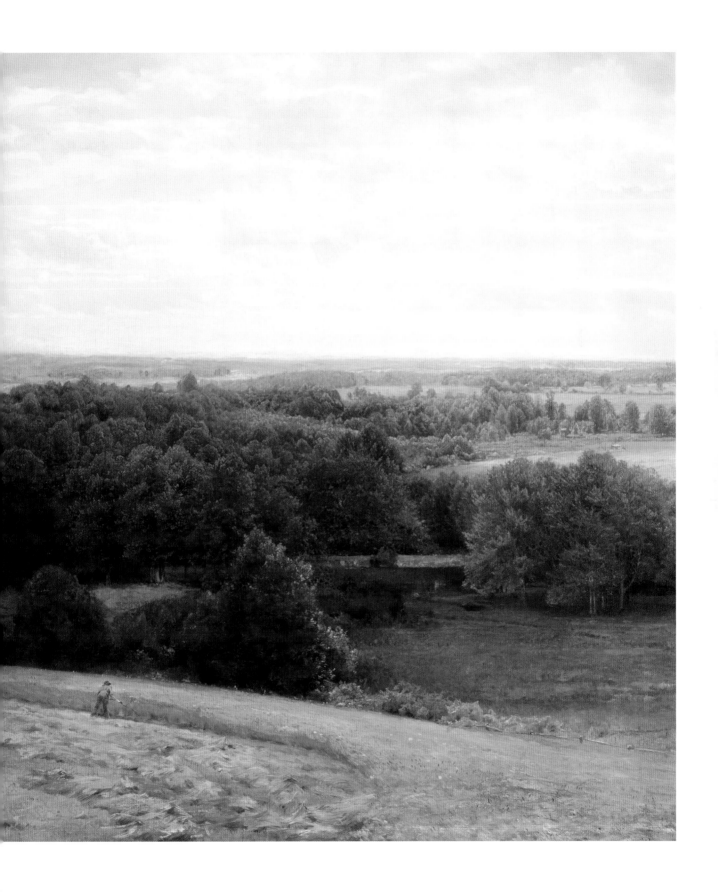

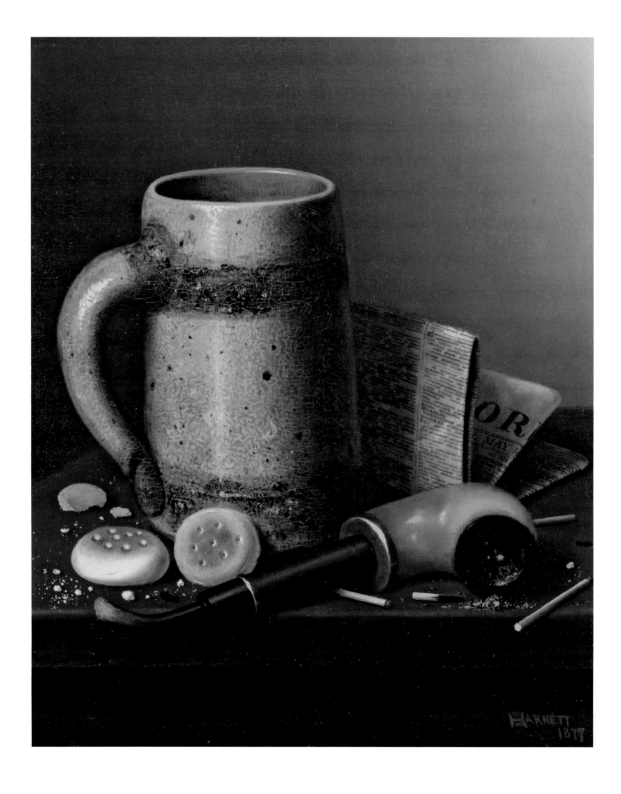

Autumn on the Brandywine River (pages 26–27) represents the work of a subsequent group of artists who journeyed to the area in search of inspiration. The collection also includes outstanding examples of the work of William Trost Richards, who lived and painted in Chester County, Pennsylvania, from 1884 to 1890. In his monumental *Valley of the Brandywine, Chester County (September)* (pages 30–31), Richards captured the beauty and quietude of the expansive, idyllic Brandywine countryside, as yet unmarred by industrialization. Richards's smaller, more impressionistic oil sketches record grain fields, cloudscapes, and weather effects observed throughout the valley and portray intimate details of the region's agrarian landscape and life.

The Heritage Collection also features a selection of American still-life and trompe-l'œil paintings, many by artists with regional connections. Still-life paintings by Philadelphia masters Raphaelle Peale and James Peale best represent the early decades of this genre, with the hyper-reality of Raphaelle Peale's *Still Life with Peach Halves* fore-shadowing the revival of trompe l'œil in American art. Popularized by William Michael Harnett, such painting attracted other masters, and John Frederick Peto and Alexander Pope soon demonstrated in their astonishingly lifelike compositions both the wit and technical virtuosity inherent in the best examples of this tradition.

The Museum's inaugural exhibition in 1971 celebrated the work of N. C. Wyeth and Howard Pyle, and since then the Brandywine has continued to promote an interest in American illustrators, particularly those with a local affiliation. Beginning with F. O. C. Darley, Arthur Burdett Frost, and Howard Pyle, the collection relates the stories of some of the most well-known artists active during what has been termed the Golden Age of Illustration. Pyle, a native of nearby Wilmington, Delaware, established a nationally renowned school of illustration there in 1900. He and his students spent several sum-mers in Chadds Ford, where they painted views of the countryside and scenes based on local history. The Museum boasts a comprehensive collection of Pyle's work: pen-and-ink drawings illustrating Arthurian legends, black-and-white oil paintings depicting scenes from American history, and *The Nation Makers* (page 9), a spirited depiction of the Revolutionary War conflict on the nearby Brandywine Battlefield. Students came from across the United States to study with Pyle, and the collection includes examples by the most successful among them: Harvey Dunn, Elizabeth Shippen Green, Violet Oakley, Maxfield Parrish, Frank Schoonover, and Jessie Willcox Smith.

William Michael Harnett
(1848–1892)
A Man's Table Reversed, 1877
Oil on canvas,
20 $^3/_4$ x 18 $^3/_4$"
Gift of Amanda K. Berls, 1980

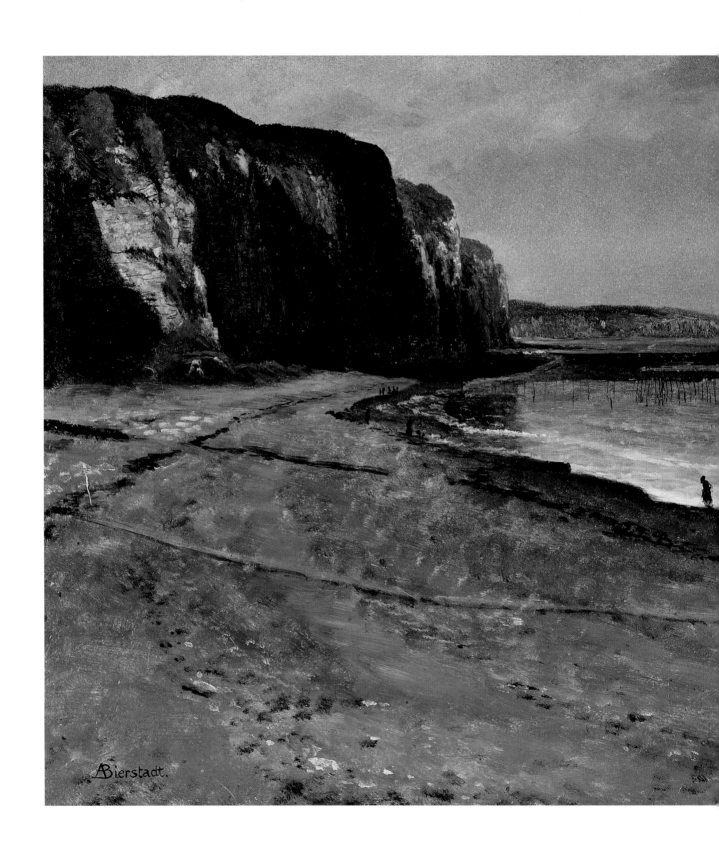

Albert Bierstadt (1830 – 1902)
Coast of California, n.d.
Oil on paper mounted on canvas,
14 x 19"
Richard M. Scaife Bequest, 2015

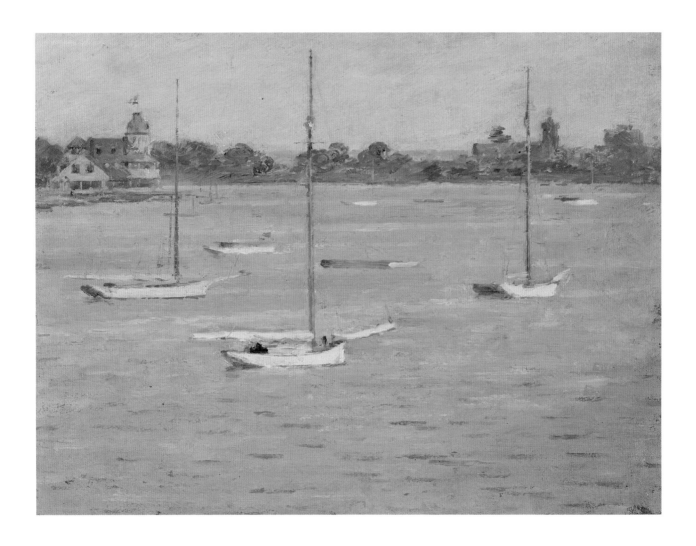

ABOVE
Theodore Robinson (1852–1896)
Yacht Club Basin, Cos Cob Harbor, 1894
Oil on wood panel, 10 x 13 $^1/_2$"
Richard M. Scaife Bequest, 2015

OPPOSITE
J. Alden Weir (1852–1919)
Misty Landscape, n.d.
Oil on canvas, 24 x 20"
Richard M. Scaife Bequest, 2015

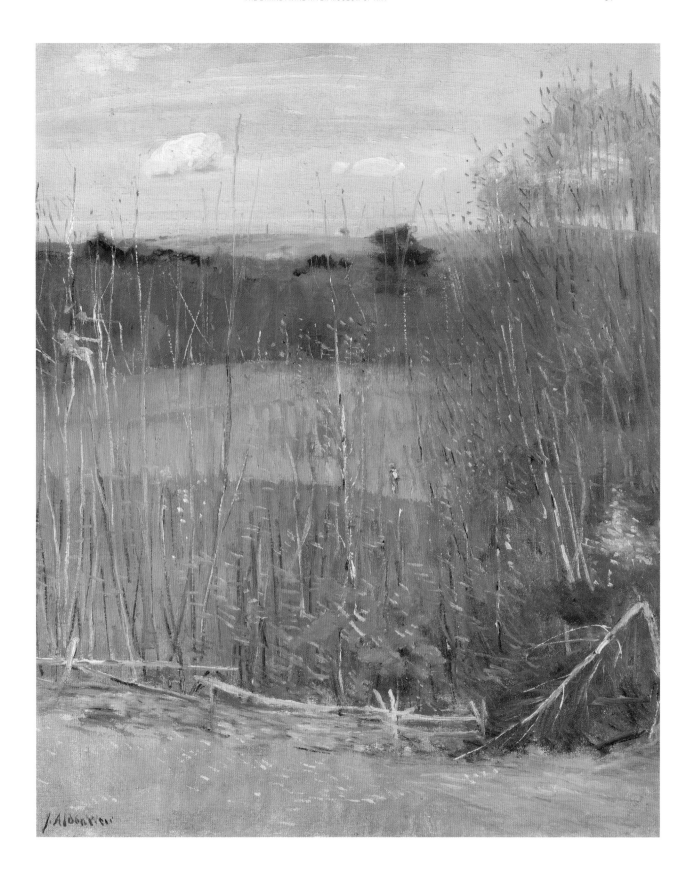

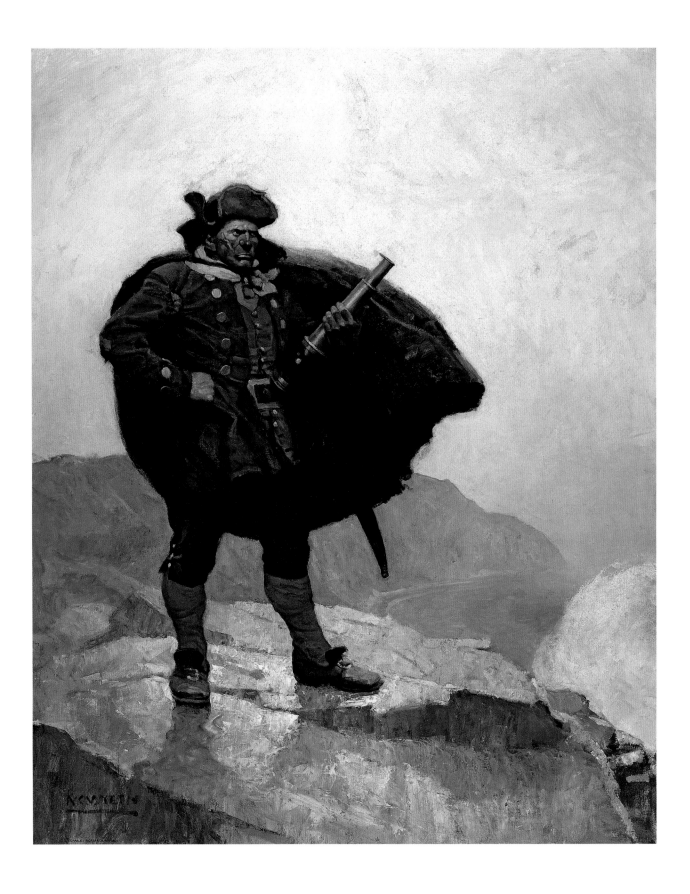

Internationally known for its holdings by three generations of members of the Wyeth family, the Brandywine always has on view a rich display of work by these iconic artists. The Museum's N. C. Wyeth collection encompasses paintings accomplished both in Chadds Ford and in Port Clyde, Maine, the two locations that have inspired Wyeth painters for more than a century. Installations of N. C. Wyeth's work include beloved paintings that illustrated such Charles Scribner's Sons classics as *Treasure Island*, *Kidnapped*, and *The Last of the Mohicans*. His most memorable characters – Captain Bill Bones (opposite), Long John Silver, David Balfour, and a host of Arthurian knights – engage visitors of all ages, proving the timeless appeal of Wyeth's romantic, imaginative creations. Outstanding examples of the lesser-known aspects of Wyeth's work – his land- and seascapes, still lifes, and portraits – contribute to a thorough understanding of his artistic depth and breadth.

A selection of Andrew Wyeth's most important Pennsylvania paintings appear in the gallery dedicated to his work. Major tempera panels, such as *Adam* (page 119), *James Loper,* and *Roasted Chestnuts* document the intimate relationships the artist established with his models, local people who gave distinct character to his Chadds Ford world. *Pennsylvania Landscape* (page 41) and *Snow Hill* reflect his profound and enduring sense of place. Like his father, Andrew Wyeth nurtured an intense engagement with the places and people of midcoast Maine. *Anna Christina* and *Siri* (page 47) masterfully embody that aspect of the artist's oeuvre. The tour de force of Andrew Wyeth's watercolor techniques may be seen in selections such as *Lobsterman (Walt Anderson)* and *North Light*, which reveal the artist's superb handling of the medium that launched his career.

N.C. Wyeth (1882-1945)
All day he hung round the cove, or upon the cliffs,
with a brass telescope, 1911
Oil on canvas, 47 1/$_4$ x 38 1/$_4$"
Endpaper illustration for *Treasure Island* (New York:
Charles Scribner's Sons, 1911), by Robert Louis Stevenson.
Bequest of Gertrude Haskell Britton, 1992

N.C. Wyeth (1882–1945)
The Water Letter, 1944
Tempera and oil on hardboard, 37 x 46"
Purchased in memory of Deo du Pont Weymouth
and Tyler Weymouth, 1981

Andrew Wyeth (1917–2009)
Pennsylvania Landscape, 1941
Tempera on panel, 35 x 47"
Bequest of Miss Remsen Yerkes, 1982

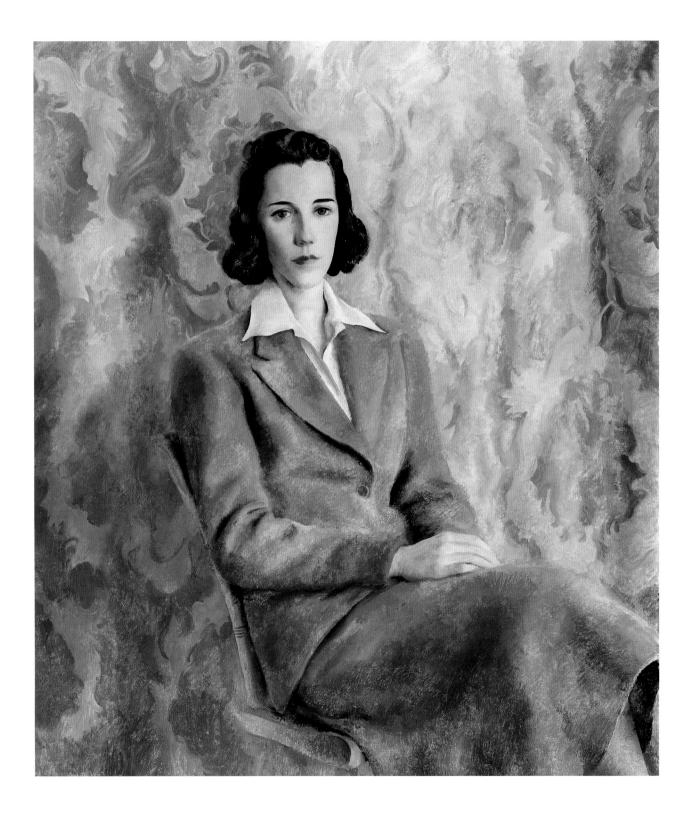

N. C. Wyeth's daughters Henriette Wyeth Hurd and Carolyn Wyeth, though perhaps less well known, were highly talented artists who developed their own distinctive styles. The Museum holds examples of Henriette Hurd's work in still life and portraiture. *Portrait of Catharine Skelly (Mrs. Joseph A. Wheelock)* (opposite), exemplifies the soft, tonalist style she favored before her move to New Mexico in 1940. Carolyn Wyeth, who chose to paint scenes of her parents' property—where she lived until her death—reduced form to simple yet bold, powerful shapes. She employed a dark palette to create haunting moods, as shown in *Nut Trees* and *Open Window* (pages 44 and 45). Henriette's husband, Peter Hurd, and John W. McCoy, the husband of N. C. Wyeth's youngest daughter, Ann, studied with N. C. Wyeth. Both of these artists are also represented—Hurd with landscapes and portraits from his native New Mexico, and McCoy with local scenes such as *Brandywine at Twin Bridges* (page 13), an eloquent evocation of the nineteenth-century landscape tradition.

Jamie Wyeth, a member of the third generation of the family to live in and draw inspiration from the Brandywine Valley, is represented at the Museum by a far-ranging selection of his work. The iconic *Draft Age* (page 51)—at once a stunning portrait and insightful commentary on the Vietnam War—attests to Wyeth's virtuosity as a young artist. *Portrait of Pig* (page 121), *Raven*, and *Angus* reveal his lifelong fascination with the physical form, attributes, and symbolism of animal and avian subjects. A series of paintings, including *Mort de Noureev*, and a large group of oil sketches and preliminary drawings chronicle Wyeth's Rudolf Nureyev project, which occupied the artist intermittently over a period of nearly thirty years. Like his father and his grandfather before him, Jamie Wyeth finds creative inspiration in the people, landscapes, and seascapes of Maine. His startlingly direct depiction of the Monhegan Island house originally built by Rockwell Kent (pages 122-123) confirms his position within coastal Maine's rich artistic tradition. The latest addition to the Brandywine's collection—*First in the Screen Door Sequence* (page 53)—is an assemblage of a found object with a life-size portrait and represents a new direction in the artist's creative explorations. In this work, Andy Warhol is seen through a painted wooden screen door, so that the image both recalls Wyeth's pivotal relationship with his friend and mentor and attests to his enduring interest in Warhol as a subject.

Henriette Wyeth
(1907-1997)
Portrait of Catharine Skelly (Mrs. Joseph A. Wheelock), 1938
Oil on canvas, 45 x 40"
Gift of Mr. and Mrs. Joseph A. Wheelock, 1974

Carolyn Wyeth (1909–1994)
Nut Trees, 1975
Oil on canvas, 28 x 32"
Museum Volunteers' Purchase
Fund, 2013

Carolyn Wyeth (1909–1994)
Open Window, 1944
Oil on canvas, 25 x 36"
Gift of Carolyn Wyeth in memory
of Mark L. Arnold, 1979

Andrew Wyeth (1917-2009)
Siri, 1970
Tempera on panel, 30$^{1}/_{2}$ x 30"
Purchased for the Museum by John T. Dorrance, Jr.;
Mr. and Mrs. Felix du Pont; Mr. and Mrs. James P. Mills;
Mr. and Mrs. Bayard Sharp; two anonymous donors;
and The Pew Memorial Trust, 1975.

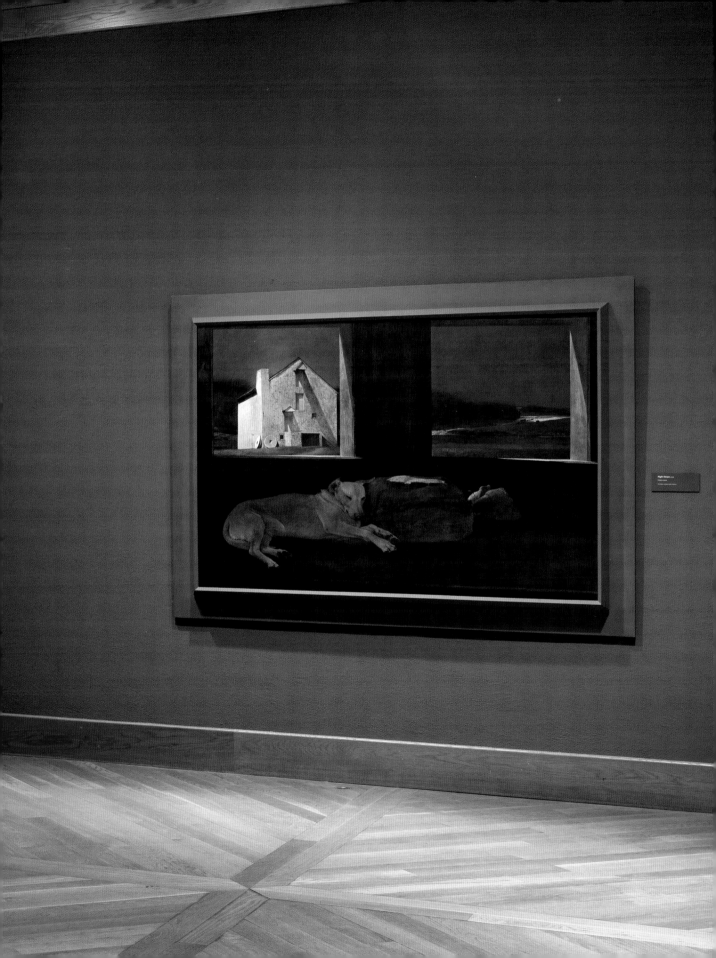

Jamie Wyeth (b. 1946)
Draft Age, 1965
Oil on canvas, 36 x 30"
Purchase made possible by Mr. and Mrs. Randy L.
Christofferson, Mr. and Mrs. George Strawbridge, Jr.,
Mary Alice Dorrance Malone Foundation, Margaret
Dorrance Strawbridge Foundation of PA I, Inc.,
The William Stamps Farish Fund, Mr. and Mrs. James W.
Stewart III, and MBNA America, 1999

The Walter and Leonore Annenberg Research Center at the Museum, made possible by a generous gift from the Annenbergs in 2004, supports scholarly investigation into the Brandywine's collections. The center's holdings comprise a large number of first edition books, important archives related to Howard Pyle and his students, and extensive archival material—films, manuscripts, and photographs—related to the Wyeth family.

To complement the permanent collection and promote new scholarship, the Museum maintains a vigorous program of changing exhibitions. In the last few years alone, the Brandywine has organized major exhibitions focusing on Horace Pippin, an African American artist from nearby West Chester, Pennsylvania; Charles Burchfield, one of America's most celebrated artists and a master water-colorist; Andrew Wyeth and his interest in botanical imagery; and James Welling, one of the country's foremost contemporary artists and one known for his bold experimentation in photography. These exhibitions have brought fresh perspec-tives to artists represented in the Brandywine's collection, while also introducing Museum visitors to the work of other celebrated figures in American art. In addition, a series of commissioned site-specific installations on the grounds outside the Museum and at its historic artists' studios has animated the very landscape that has inspired generations of artists.

Jamie Wyeth (b. 1946)
First in the Screen Door Sequence, 2015
Oil on canvas on honeycomb aluminum
support with American folk art "found object"
construction of wood, metal, screen,
and hardware, 82 x 33 $^1/_2$ x 3 $^7/_8$"
Gift of George A. Weymouth, 2016

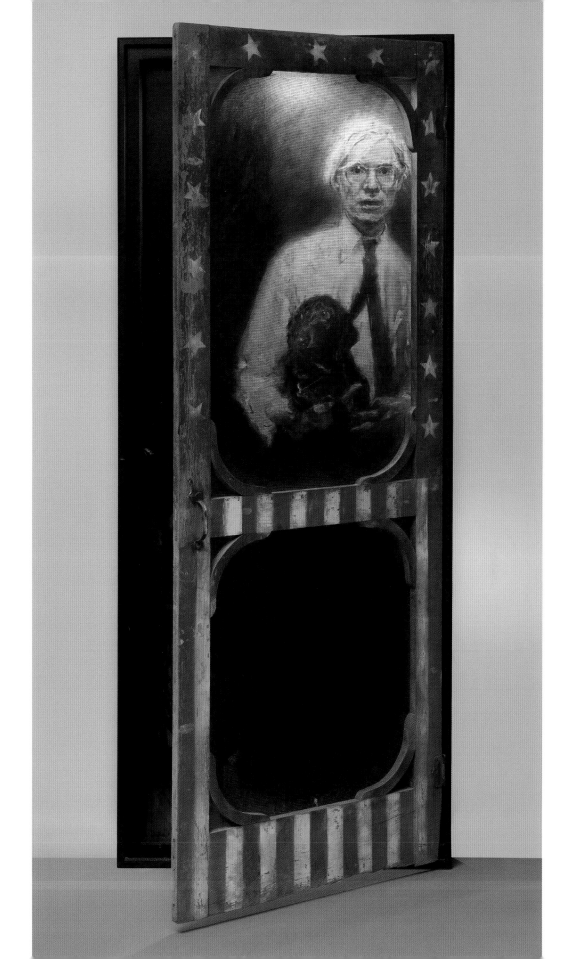

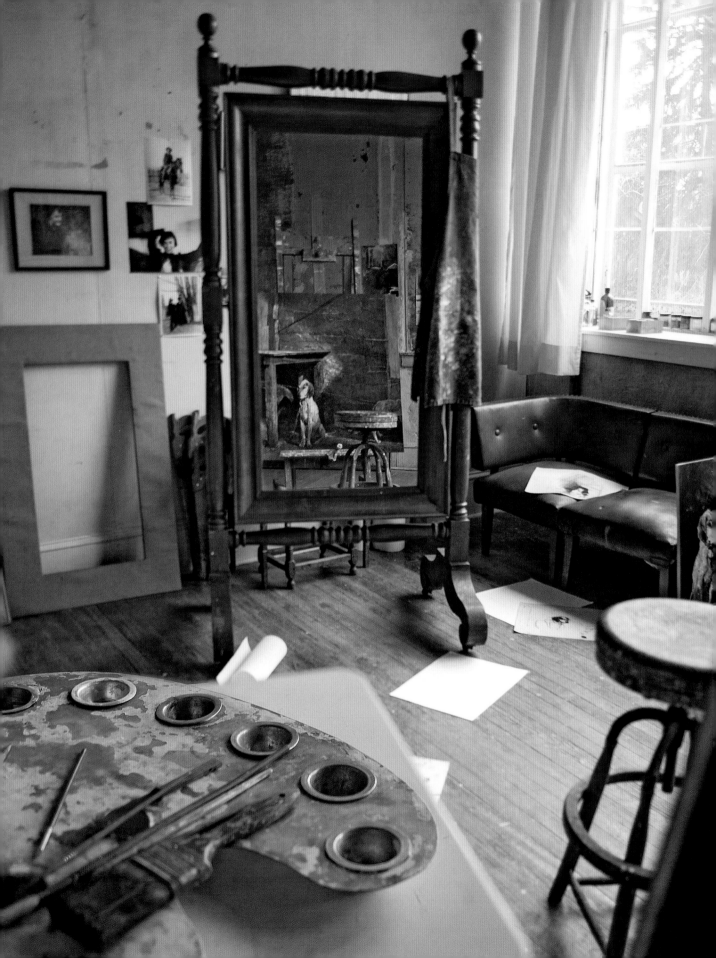

IN THE ARTISTS' FOOTSTEPS

Three matchless sites, all recognized as National Historic Landmarks, are integral parts of the Brandywine River Museum of Art. The N. C. Wyeth House and Studio, the Andrew Wyeth Studio, and Kuerner Farm provide visitors with an immersive experience, a close encounter with the intimate spaces and inspirational settings where three generations of Wyeths have lived and worked.

Less than one mile from the Museum, N. C. Wyeth's house and studio were acquired in 1982 through the generosity of the artist's children. N. C. Wyeth purchased the eighteen-acre property in 1911 with the proceeds from his *Treasure Island* commission. In the same year, the house and studio were built. Guided tours of the charming, two-story brick house with its country furnishings focus on the creative environment in which Wyeth and his wife, Carolyn, raised their five talented children. Dramatically situated at the top of the sloping site, the studio, with a spectacular Palladian window on the façade of the original 1911 building, commands a breathtaking setting that speaks of the Thoreauvian sense of place that Wyeth held dear. Inside, the soaring height of the studio's spaces evokes the artist's robust personality and the larger-than-life characters he painted there. Props gathered by the artist, such as his collections of firearms, edged weapons, Native American objects (notably the early nineteenth-century birchbark canoe that hangs from the ceiling), and a reference library with hundreds of volumes shed light on his working methods. In 1923, Wyeth constructed an adjoining studio to accommodate the growing number of mural commissions he received. Visitors take several steps down into this space to experience the artist's enormous canvas *William Penn: Man of Vision · Courage · Action* (a generous gift to the Museum from the Penn Mutual Life Insurance Company). This mural and a moveable stair tower testify to the scale on which Wyeth worked as he completed more than fifteen mural commissions during the last two decades of his career. The immediacy of all the objects and their evocative installation in these studios can transport visitors back in time, suggesting that the artist has only just stepped out and will return at any moment.

The Andrew Wyeth Studio

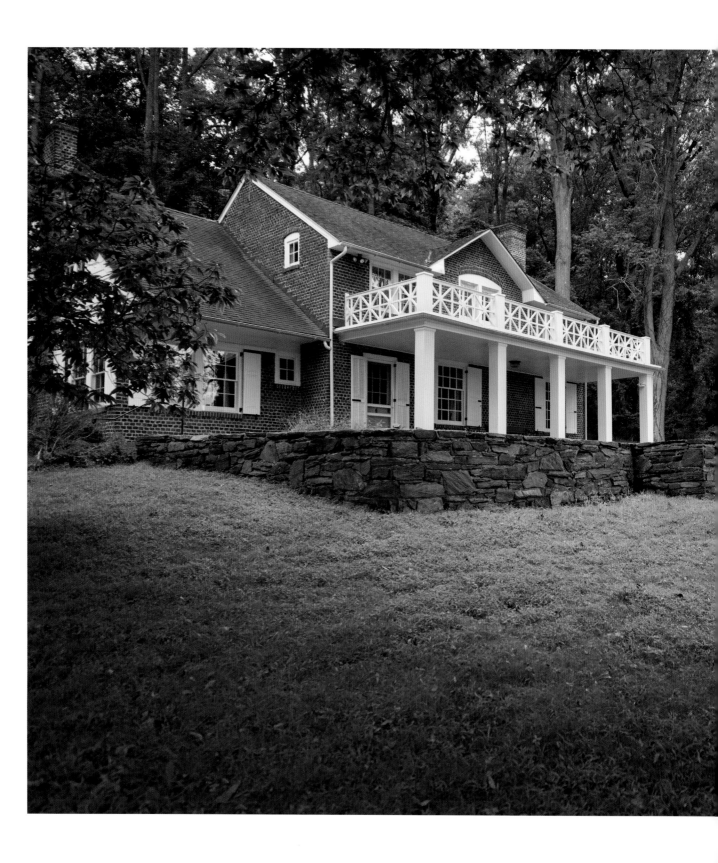

The N. C. Wyeth House, constructed in 1911

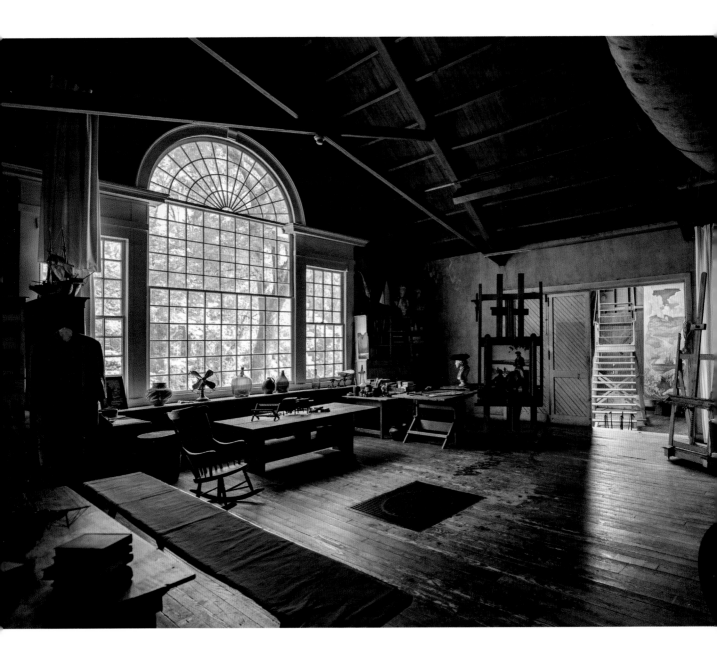

ABOVE
Paint table detail in the N. C. Wyeth Studio

LEFT
N. C. Wyeth's 1911 studio, looking
toward the 1923 addition

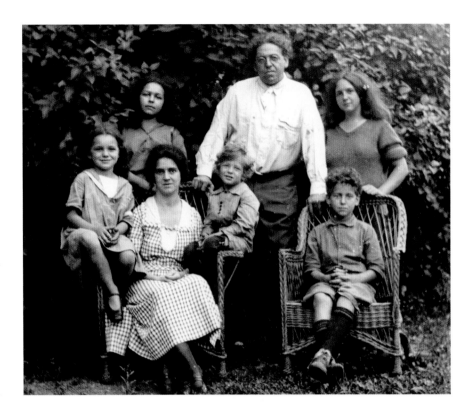

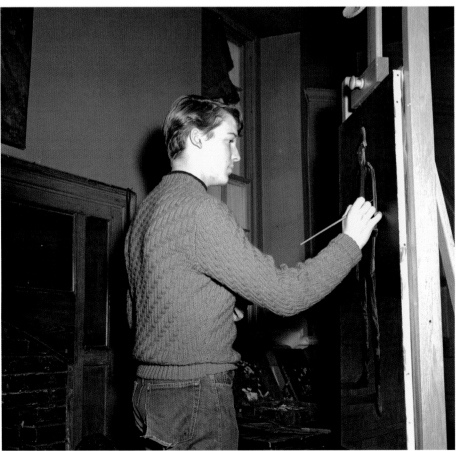

OPPOSITE, TOP
N. C. and Carolyn Bockius Wyeth,
circa 1922, with their family,
(left to right) Ann, Carolyn,
Andrew, Nathaniel, and Henriette.
Courtesy of the Wyeth
Family Archives

OPPOSITE, BOTTOM
Christian Sanderson (1882–1966)
Jamie Wyeth at his easel in the
Andrew Wyeth Studio, early 1960s.
Courtesy of the Christian C. Sanderson
Museum, Chadds Ford, PA

BELOW
Battleground, 1981, by Peter
Ralston, with Wyeth's 1981
tempera *Battleground* on
the easel

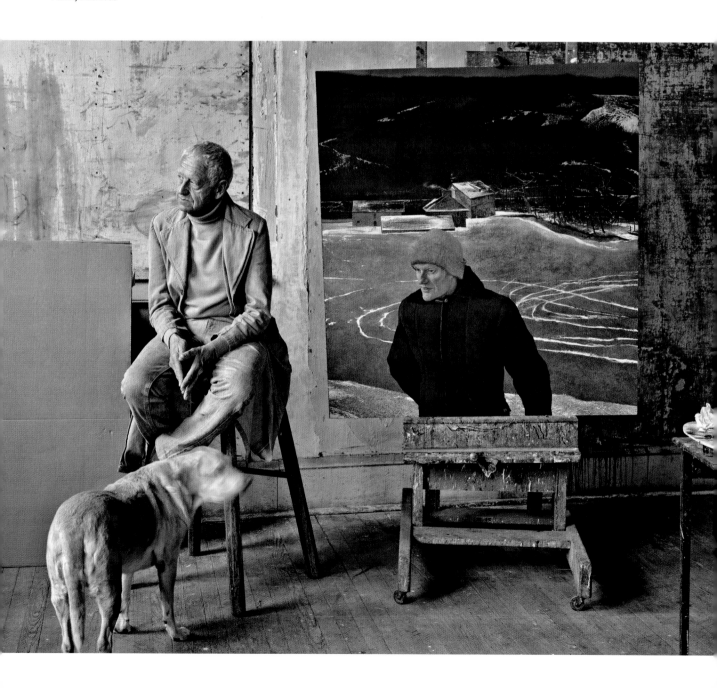

Completely different in mood and the intimacy of its architectural spaces is the studio of Andrew Wyeth, given in 2010 to the Brandywine River Museum of Art by Betsy Wyeth, the artist's widow. This was Andrew Wyeth's principal Chadds Ford workplace for almost seven decades; here, in a building originally erected as a one-room schoolhouse, Andrew Wyeth created thousands of drawings and water-colors and painted his most enduring Pennsylvania temperas, masterpieces such as *Pennsylvania Landscape*, *Raccoon*, and *Roasted Chestnuts*. For twenty years, Andrew and Betsy also lived in this building, the home in which they raised their sons, Nicholas and Jamie. Once the family moved to another property in Chadds Ford, however, the building became Andrew Wyeth's highly personal realm, an extremely private space devoted solely to his artistic practice. Sparsely furnished and lit wholly by natural light, the somber-colored rooms suggest Wyeth's own limited palette. Examples of his art materials on display—papers, pigments, and panels—speak to the technical side of his artistry; costumes and uniforms, more than nine hundred miniature military figures, and a reel-to-reel projector attest to the artist's lifelong interests; and books in his studio library provide fascinating insight into the artists whose work Wyeth found inspirational.

A more focused study of Andrew Wyeth's art is presented at the Museum's Kuerner Farm, a site that stimulated the artist's creativity for more than fifty years. The white stucco farmhouse built in the early nineteenth century and a red bank barn constructed later in the same century sit amid thirty-three acres of gently rolling pasture. Both buildings and the landscape are preserved through the extraordinary generosity of Karl Kuerner Jr. and his family, who, in 1999, donated the farm to the Brandywine. As a boy of about nine or ten, Andrew Wyeth met Karl Kuerner Sr. and his wife, Anna, and became fascinated by this family of German immigrants who arrived at the farm in the mid-1920s to operate a dairy. Over decades, Wyeth developed a complex relationship with Karl Kuerner, the Kuerner family, and the farmscape, which he explored in hundreds of drawings, watercolors, and temperas that confirm the intense, abiding inspiration that he found there.

OPPOSITE, TOP LEFT
A detail of Andrew Wyeth's collection of miniature soldiers

OPPOSITE, TOP RIGHT
View from the Studio library's window

OPPOSITE, BOTTOM
Entrance to the Andrew Wyeth Studio

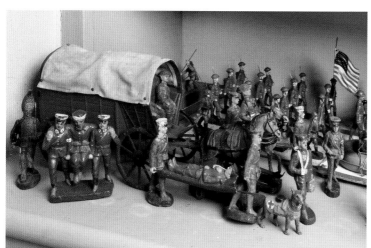

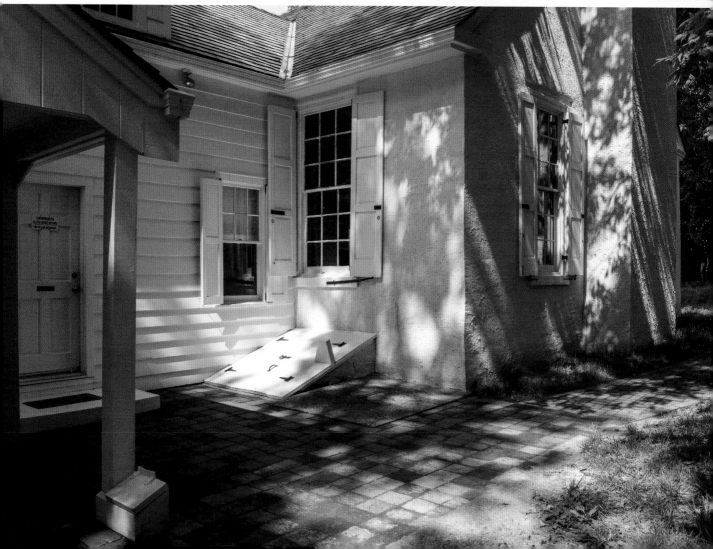

ABOVE
James Welling (b. 1951)
Evening at Kuerners, 2010
Inkjet print on paper, 15 5/8 x 23 1/2"
Gift of the artist, 2016

OPPOSITE
Kuerner farmhouse kitchen

Fulfilling the extraordinary vision shaped a half century ago, the Brandywine River Museum of Art has grown from conception to commanding presence in the cultural landscape of the region and beyond, just as the Brandywine Conservancy has become a nationally recognized advocate of land and water preservation. Respecting its treasured heritage, the Museum celebrates American art—historic and contemporary, regional and national—with a robust slate of exhibitions, publications, and programs, interpreting traditional subjects within a fresh, invigorating context and exploring new interests with innovative approaches. Thanks to continued support from generous donors, the Brandywine's ever-growing art collection contains work of depth, breadth, and quality that can be sampled in these pages.

From William Trost Richards's luminist views of the Brandywine Valley to James Welling's conceptual representation of the riverbank in early summer, the Museum's richly diverse collection, made all the more resonant by its remarkable setting, engages visitors of all ages. The interaction can be personal or collective, entertaining or contemplative, even catalytic—yet it is always rooted in the discovery of the dynamic intersection of art and nature, the Brandywine experience.

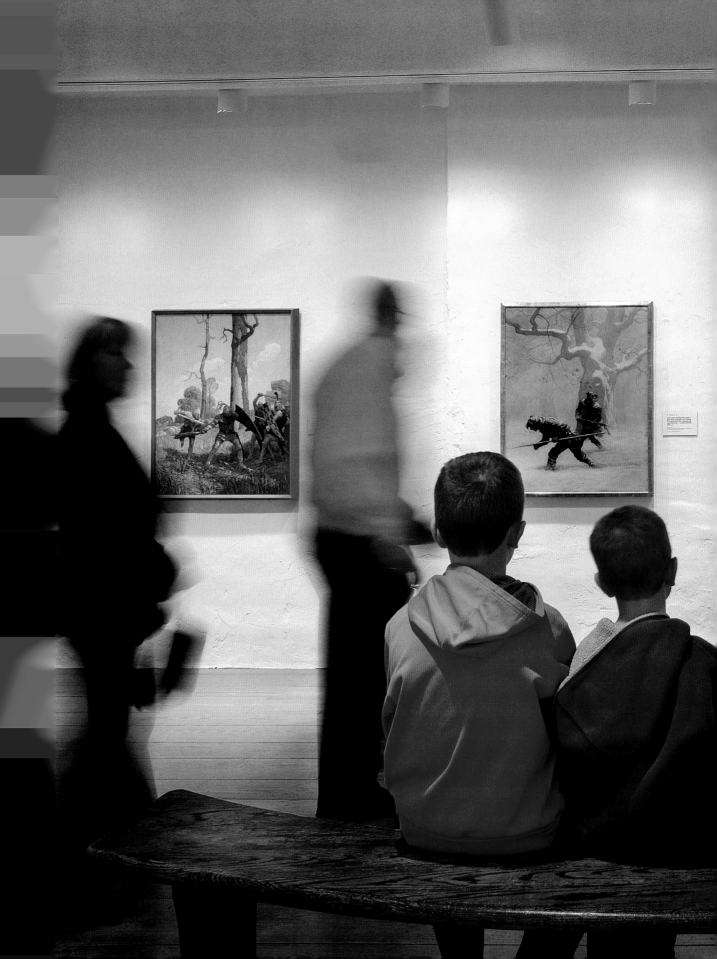

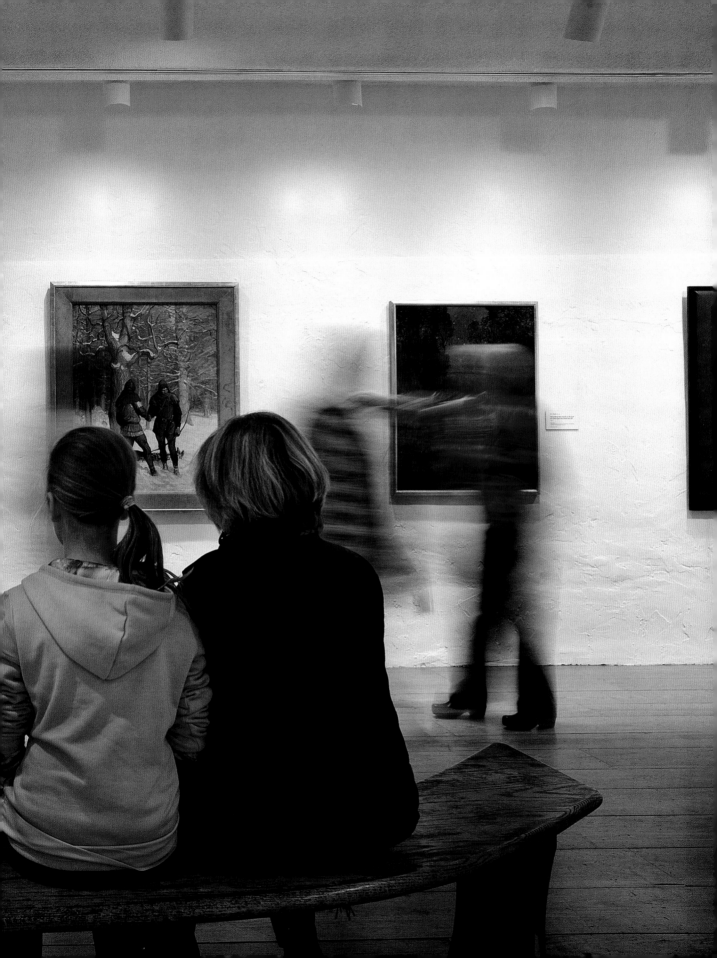

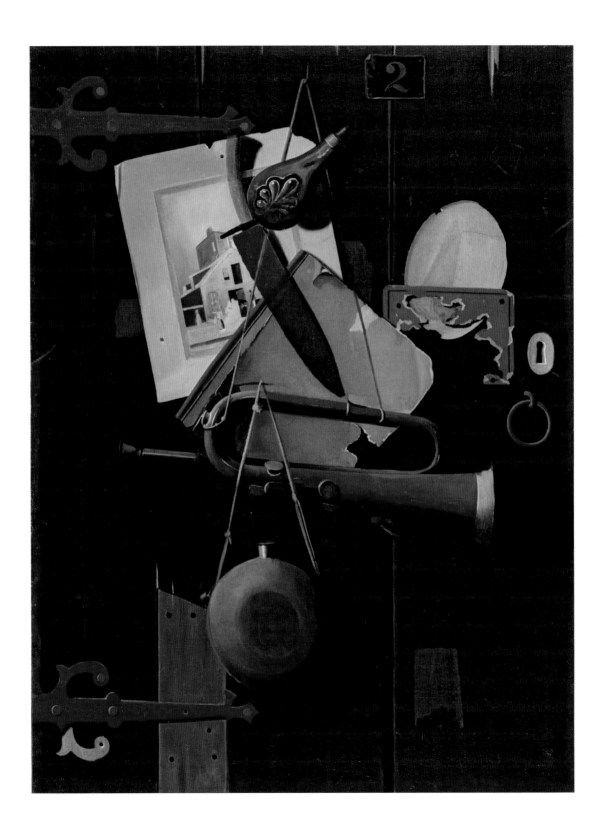

HIGHLIGHTS OF THE COLLECTION

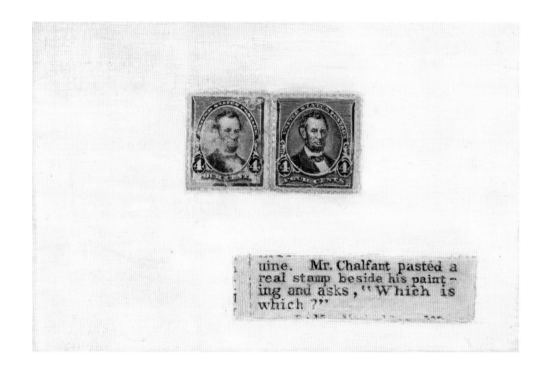

OPPOSITE
John Frederick Peto (1854-1907)
Bowie Knife, Keyed Bugle and Canteen, 1890s
Oil on canvas, 40 x 30"
Gift of Amanda K. Berls, 1980

ABOVE
Jefferson David Chalfant (1856-1931)
Which Is Which?, ca. 1890
Oil on wood panel with printed paper,
3 $^5/_8$ x 5 $^3/_8$"
Gift of Mr. and Mrs. Richard M. Scaife
and the Allegheny Foundation, 1997

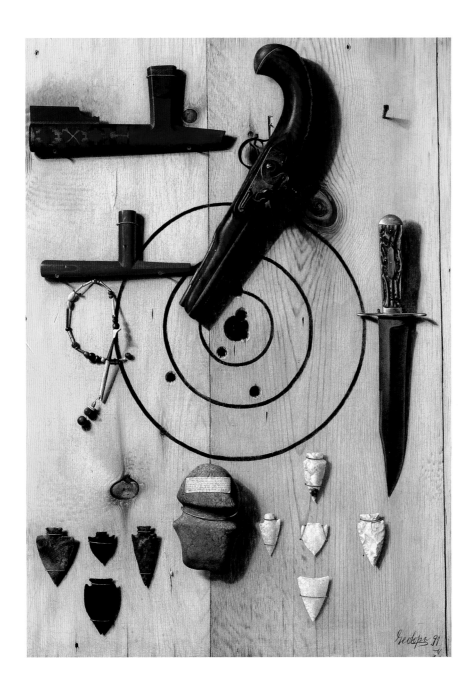

George Cope (1855–1929)
Indian Relics, 1891
Oil on canvas, 30 1/4 x 22"
Museum Volunteers' Purchase Fund, 1977

George Cope (1855–1929)
The Hunter's Equipment
(The Hunter's Yellow Jacket), 1891
Oil on canvas, 32 x 52"
Purchased through the generosity of Richard M. Scaife
and the Allegheny Foundation, 1992

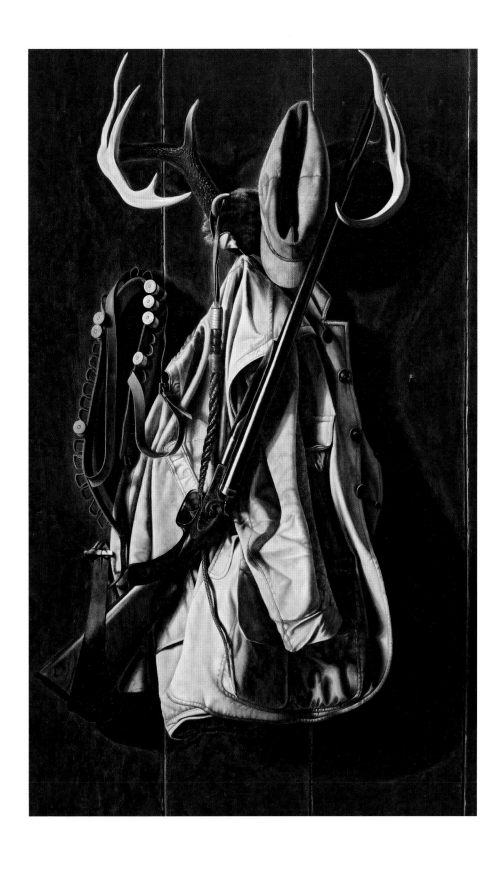

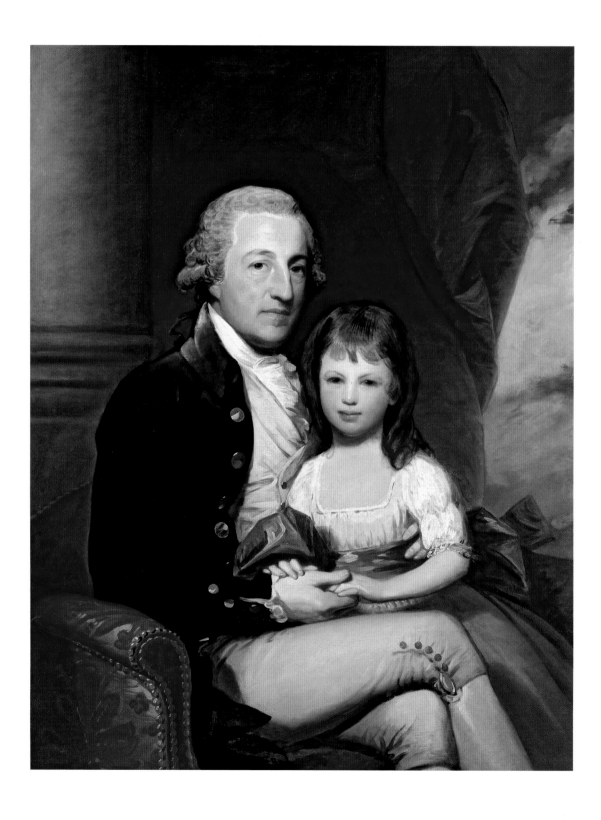

Gilbert Stuart (1755–1828)

*Robert Hare, Sr., and His Daughter
Martha,* mid 1780s

Oil on canvas, 47 $^1/_4$ x 37 $^5/_8$"

Gift of Hope, Esther Binney, and
Charles Hare, 2005

Thomas Sully (1783–1872)

Esther Cox Binney, 1836

Oil on canvas, 30 x 24 $^7/_8$"

Gift of Hope, Esther Binney,
and Charles Hare, 2005

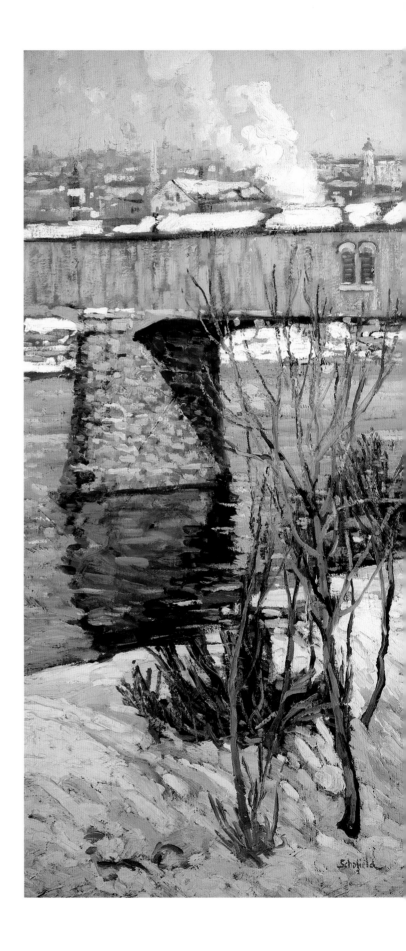

Walter Elmer Schofield (1867–1944)
*Covered Bridge on the Schuylkill
(The Red Bridge)*, ca. 1913
Oil on wood panel, 10 x 13 ¹/₂"
Richard M. Scaife Bequest, 2015

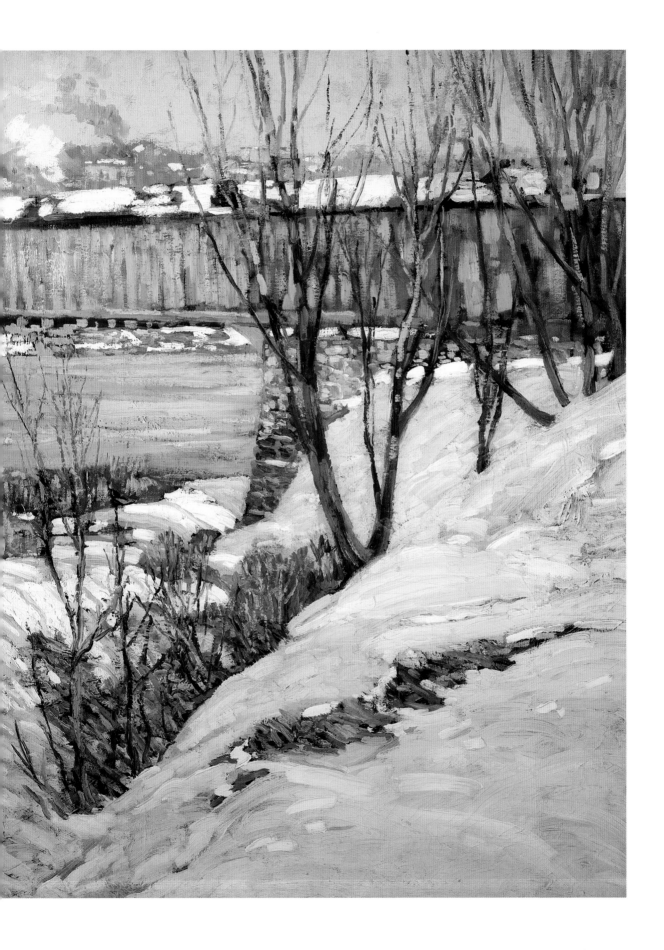

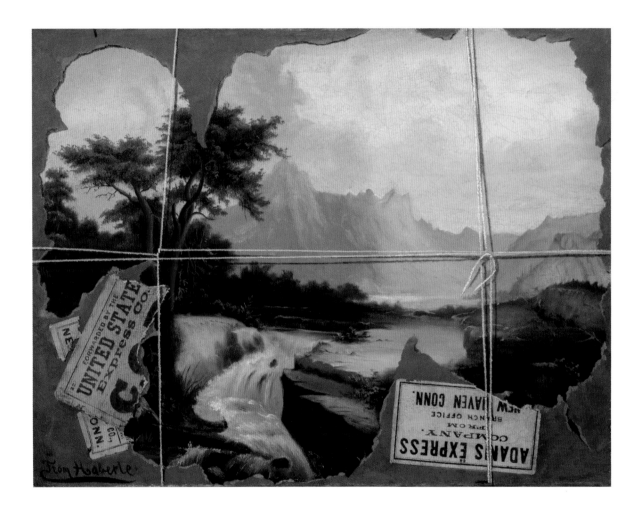

John Haberle (1856-1933)
Torn in Transit, 1890-1895
Oil on canvas, 13 $^1/_2$ x 17"
Gift of Amanda K. Berls, 1980

John Frederick Peto (1854–1907)
Five Dollar Bill, ca. 1885
Oil on canvas, 10 $^1/_4$ x 14"
Gift of Amanda K. Berls, 1980

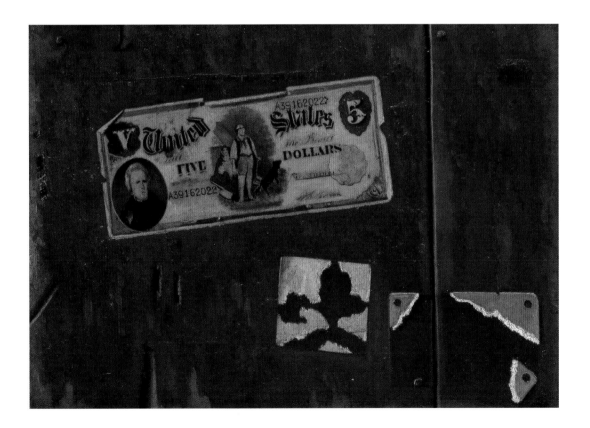

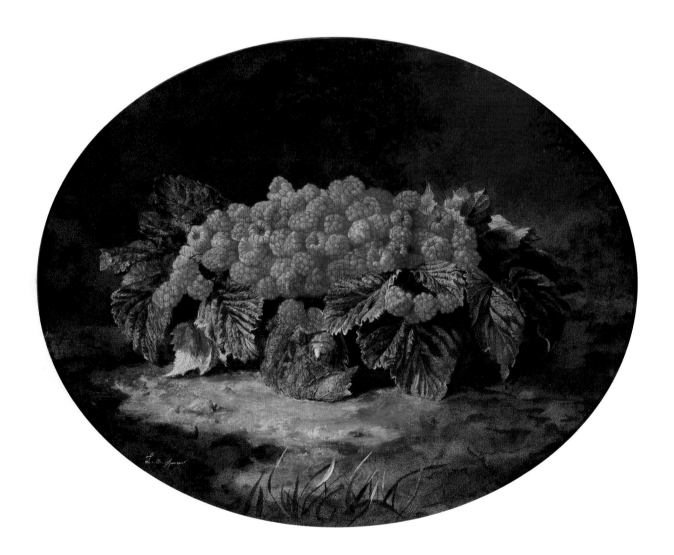

Lilly Martin Spencer (1822–1902)
Raspberries, n.d.
Oil on canvas, 25 x 29"
Richard M. Scaife Bequest, 2015

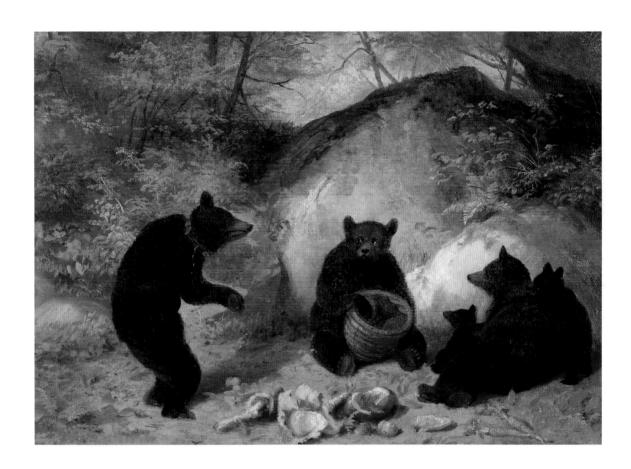

William H. Beard (1825-1900)
Five Bears, 1869
Oil on canvas, 18 x 24"
Richard M. Scaife Bequest, 2015

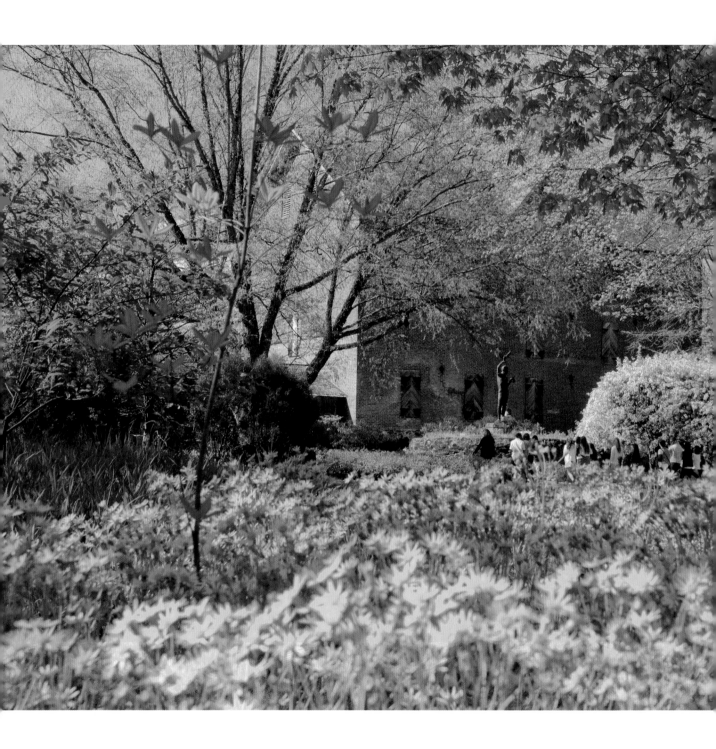

Thomas Moran (1837–1926)
A Passing Shower, 1885
Oil on wood panel, 12 $^1/_2$ x 22"
Richard M. Scaife Bequest, 2015

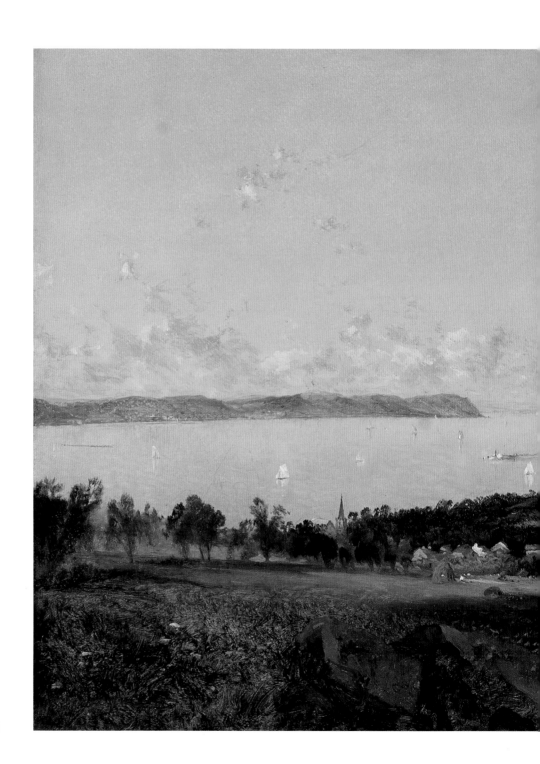

John Frederick Kensett
(1816–1872)
*Hudson River View from
Dobbs Ferry, New York*, n.d.
Oil on canvas, 14 x 24"
Richard M. Scaife Bequest, 2015

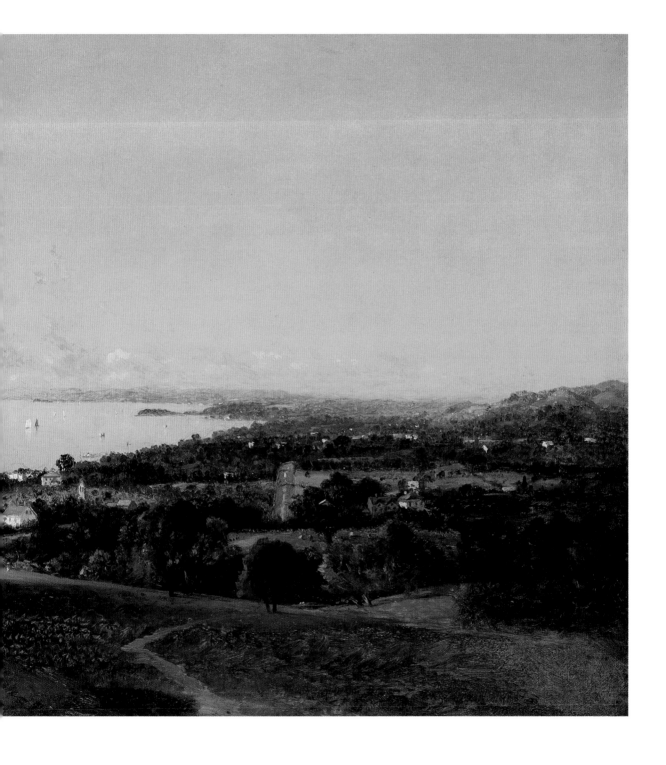

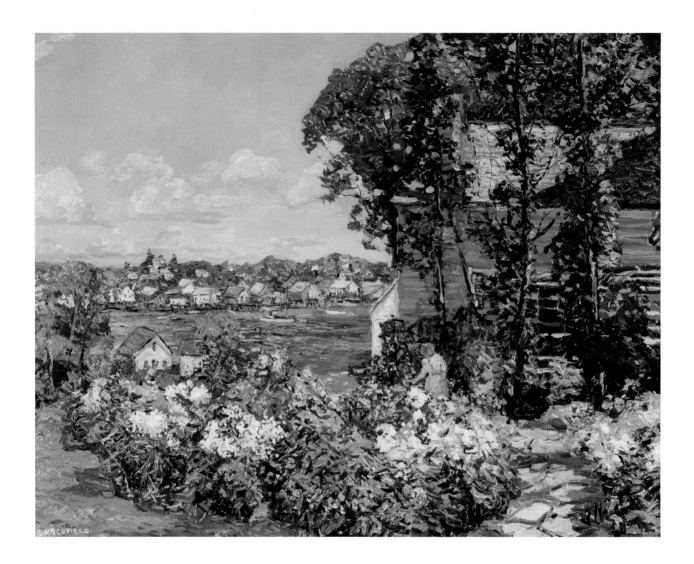

Edward W. Redfield (1869–1965)
Garden of the Girls, ca. 1928–1930
Oil on canvas, 32 x 40"
Richard M. Scaife Bequest, 2015

Edward Potthast (1857–1927)
Beach Scene, Coney Island, 1915–1918
Oil on wood panel, 11 $^7/_8$ x 16"
Richard M. Scaife Bequest, 2015

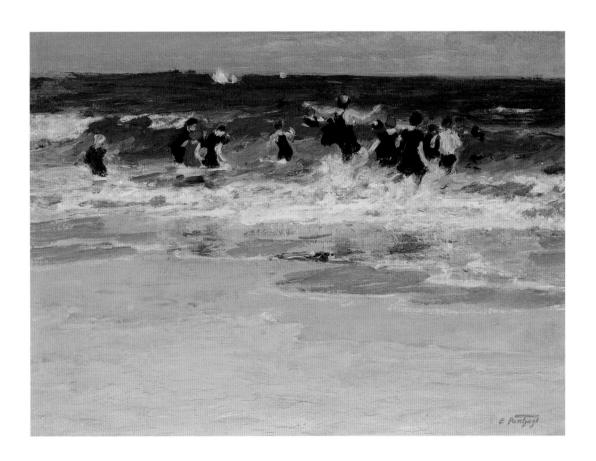

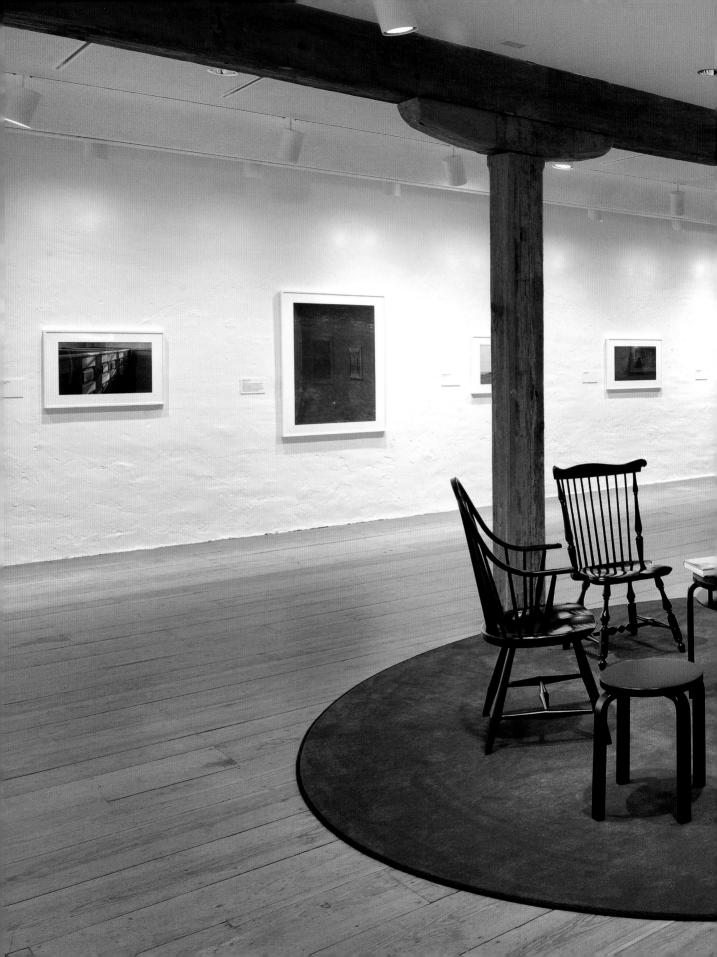

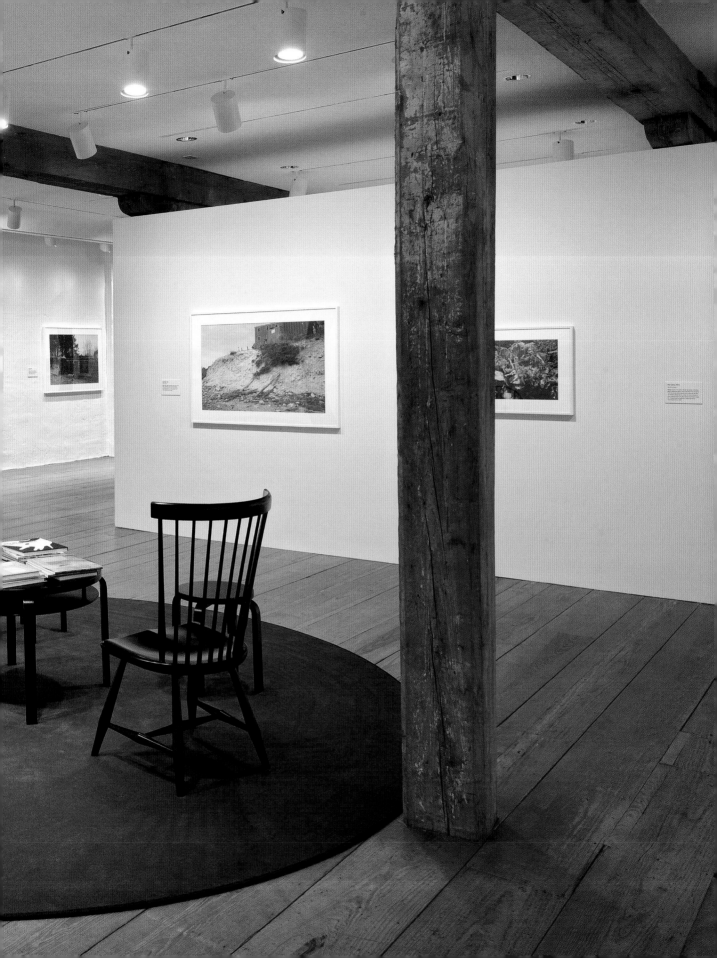

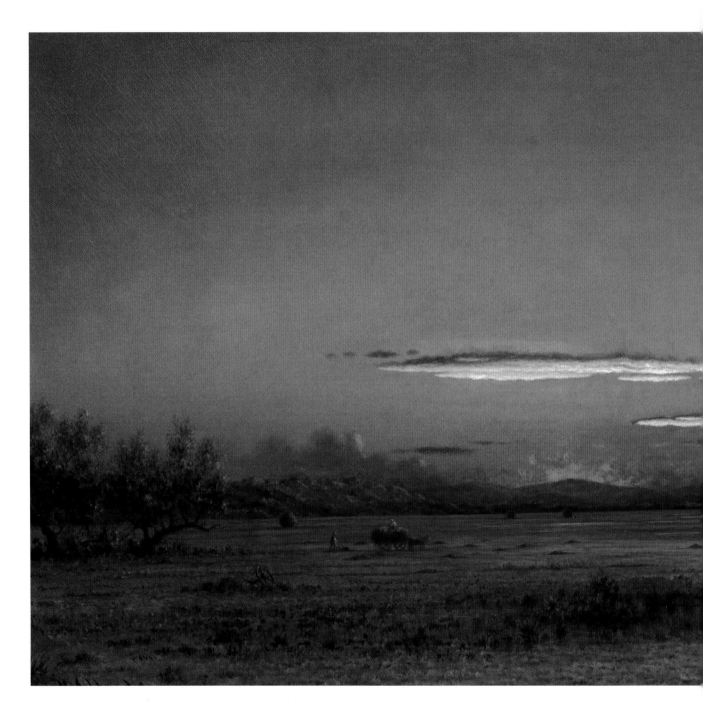

Installation of *Things Beyond Resemblance:*
James Welling Photographs
August 8–November 15, 2015

Martin Johnson Heade (1819–1904)
New Jersey Salt Marsh, ca. 1875-76
Oil on canvas, 17 x 36 $^{1}/_{4}$"
Richard M. Scaife Bequest, 2015

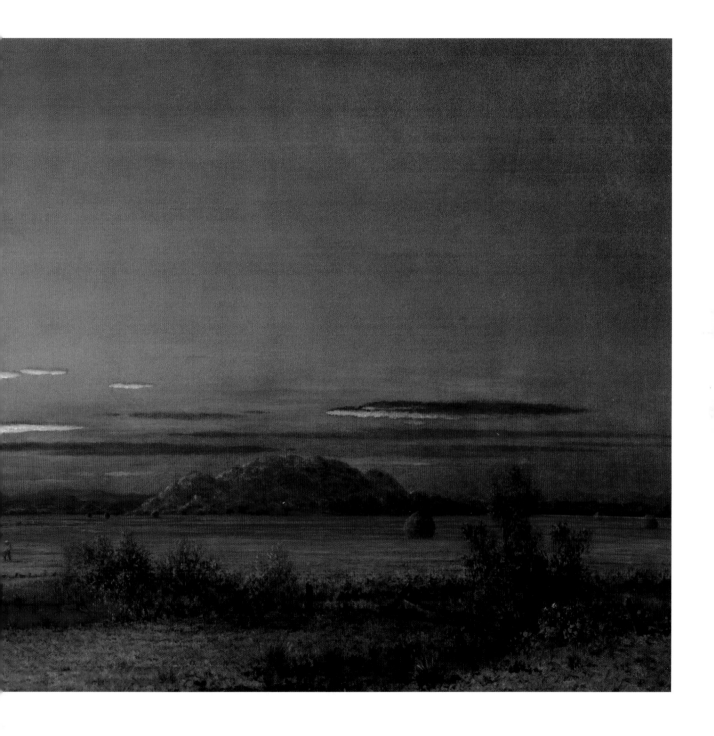

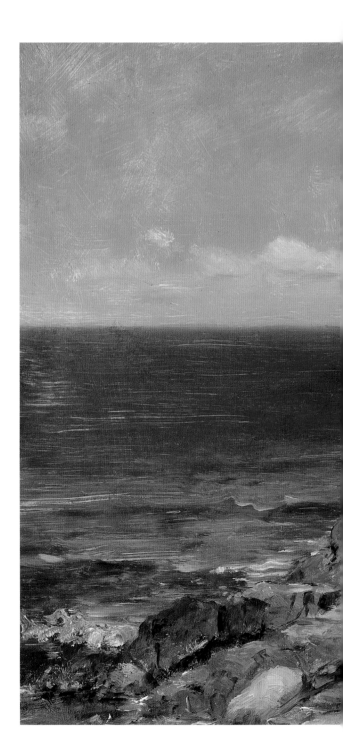

Worthington Whittredge (1820-1910)
Narragansett Bay, ca. 1880
Oil on board, 19 x 26"
Richard M. Scaife Bequest, 2015

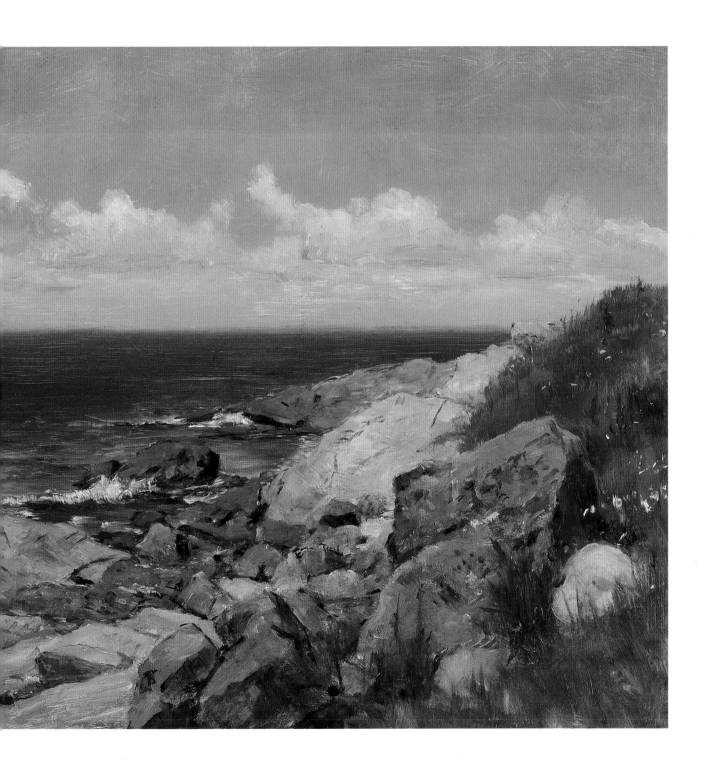

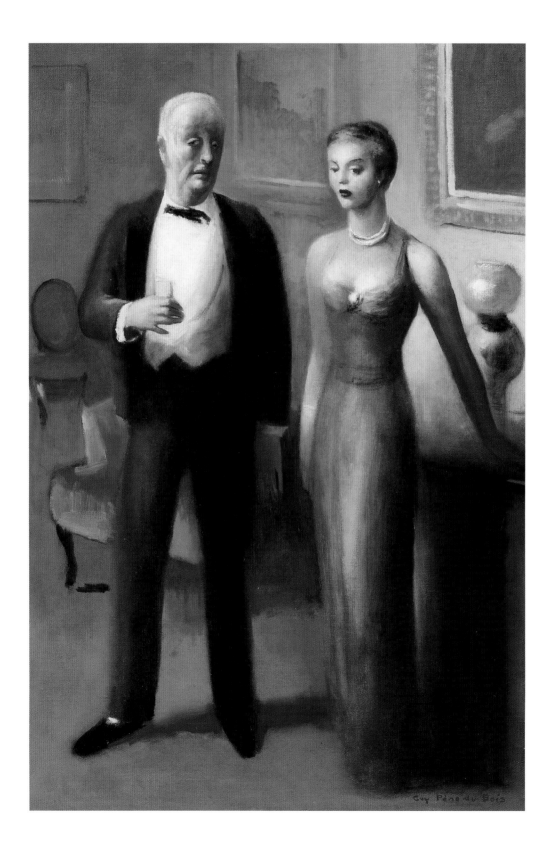

Guy Pène du Bois (1884–1958)
The Appraisal, 1926
Oil on canvas, 38 x 28 $^1/_2$"
Richard M. Scaife Bequest, 2015

John La Farge (1835–1910)
Flowers, Blue Iris, with Trunk of
Dead Apple Tree, 1871
Oil on wood panel, 12 x 9 1/2"
Richard M. Scaife Bequest, 2015

John La Farge (1835–1910)
Fountain in Our Garden at Nikko, 1886
Oil on wood panel, 11 3/4 x 9 3/4"
Richard M. Scaife Bequest, 2015

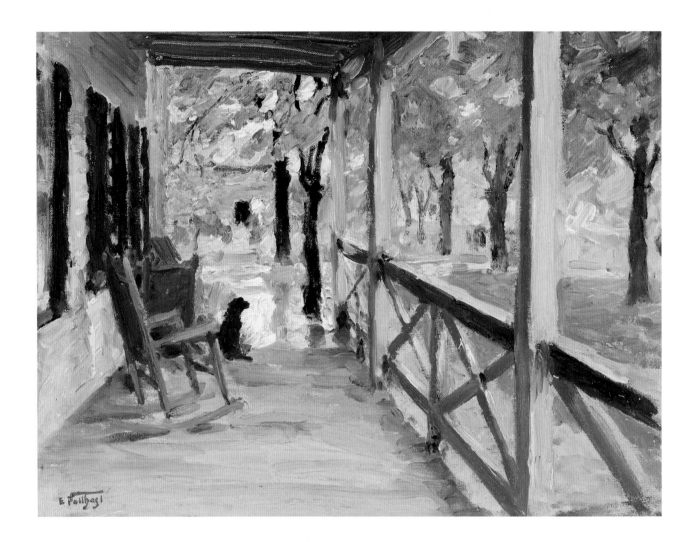

Edward Potthast (1857–1927)
The Front Porch, n.d.
Oil on canvas board panel,
11 $^7/_8$ x 15 $^7/_8$"
Richard M. Scaife Bequest, 2015

William Merritt Chase
(1849–1916)
The Tow Path, n.d.
Oil on canvas, 10 x 14 $^1/_2$"
Richard M. Scaife Bequest, 2015

The N. C. Wyeth Studio

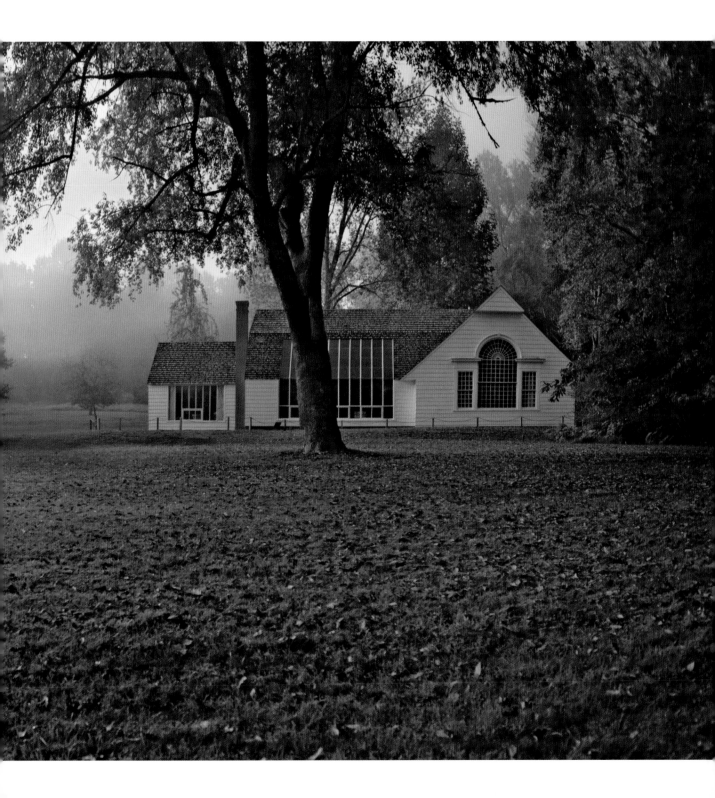

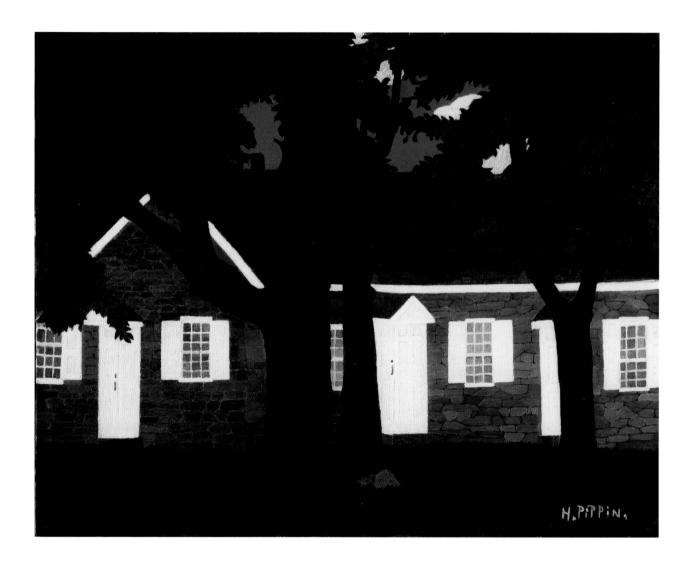

Horace Pippin (1888–1946)
Birmingham Meeting House III, 1941
Oil on fabric board, 16 x 20"
Museum Volunteers' Purchase Fund
and other funds, 2011

Horace Pippin (1888–1946)
Floral Still Life, ca. 1944
Oil on board, 10$\frac{1}{8}$ x 14$\frac{1}{8}$"
Museum purchase, 2003

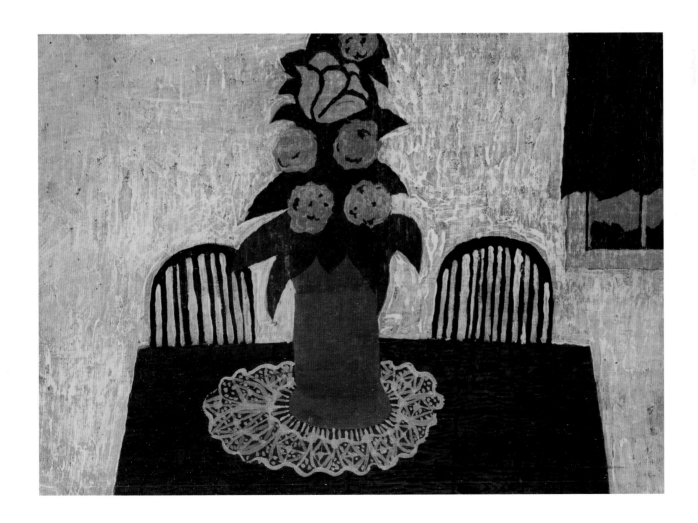

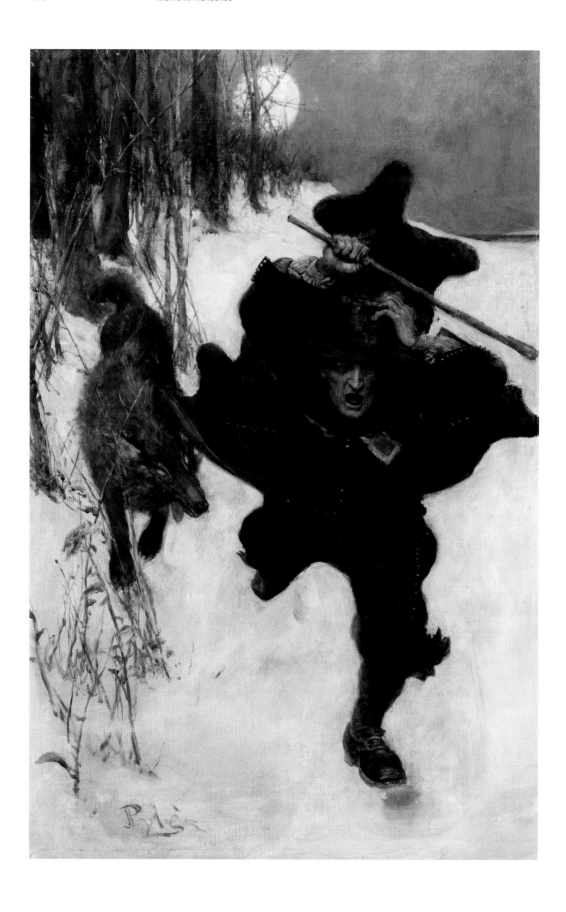

Howard Pyle (1853-1911)
The Wolf and Doctor Wilkinson (Once it chased Doctor Wilkinson into the very town itself), 1909
Oil on canvas, 27 $^7/_8$ x 18 $^1/_8$"
Illustration for "The Salem Wolf" by Howard Pyle, *Harper's Monthly Magazine*, December 1909
Gift of Mr. and Mrs. Howard P. Brokaw, 2007

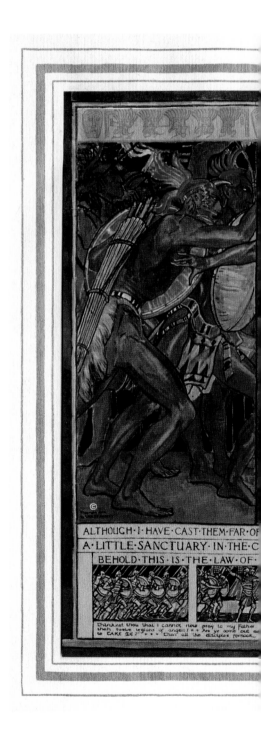

After Violet Oakley (1874–1961)
Plate 14 depicting Senate Chamber, Panel No. 1, in Violet
Oakley, *The Holy Experiment; A Message to the World
from Pennsylvania*. Limited edition, #97 of 500.
Philadelphia: Privately Printed, 1922. Museum
Volunteers' Purchase Fund, 1978.
Walter and Leonore Annenberg Research Center,
Brandywine River Museum of Art

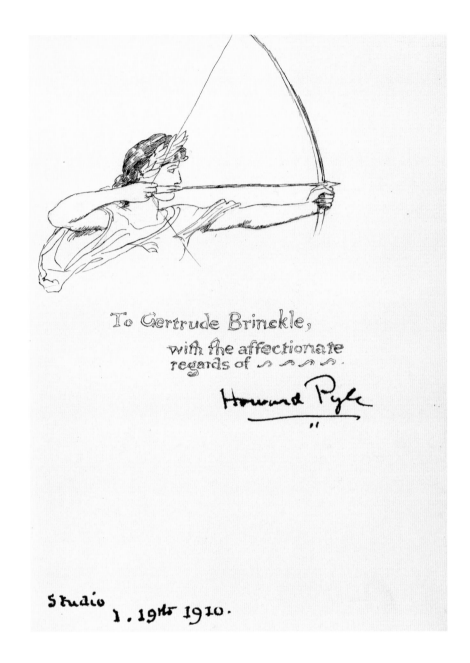

To Gertrude Brinckle,
with the affectionate
regards of

Howard Pyle

Studio 1 . 19th 1910.

Howard Pyle (1853–1911)
Inscription and drawing on front flyleaf of
The Merry Adventures of Robin Hood (New
York: Charles Scribner's Sons, 1909) to his
secretary, Gertrude Brincklé. Gift of Howard
Pyle Brokaw, 2007. Walter and Leonore
Annenberg Research Center, Brandywine
River Museum of Art

Thornton Oakley (1881–1953)
Untitled sketches from untitled sketchbook
of a trip to Singapore and other places, no
date. Gift of Lansdale Oakley Humphreys.
Walter and Leonore Annenberg Research
Center, Brandywine River Museum of Art

Thornton Oakley (1881–1953)
"Kittery Point," Monday the 22nd, from
A Journal of a Pittsburgh Trip in the Year
1898. Unpublished manuscript, 1898.
Gift of Lansdale Oakley Humphreys. Walter
and Leonore Annenberg Research Center,
Brandywine River Museum of Art

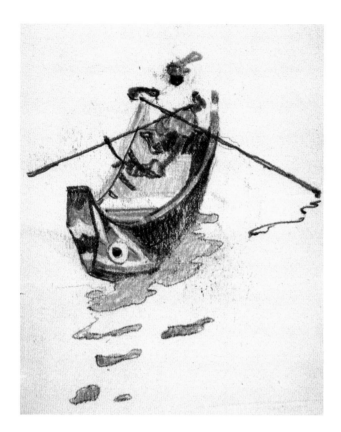

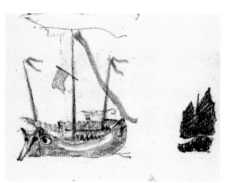

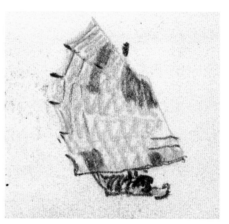

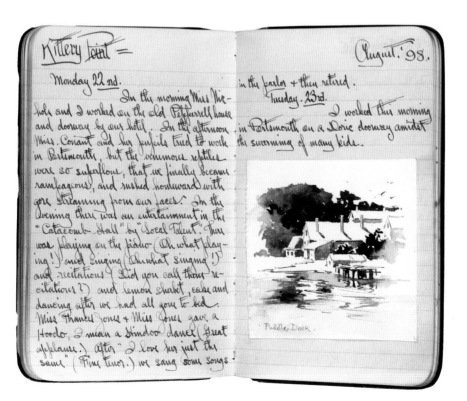

Kittery Point = August. '98.

Monday 22 nd. in the parlor + then retired.
 In the morning Miss Ni- Tuesday. 23rd.
hols and I worked on the old Pepperell house I worked this morning
and doorway by our hotel. In the afternoon in Portsmouth on a Doric doorway amidst
Miss Conant and her pupils tried to work the swarming of many kids.
in Portsmouth, but the venimous reptiles
were so superflous, that we finally became
rampageous, and rushed homeward with
gore streaming from our faces. In the
evening there was an entertainment in the
"Catacomb Hall" by "Local Talent". There
was playing on the piano (Oh what play-
ing!) and singing (Oh what singing!)
and recitations (Did you call those re-
citations?) and lemon sherbet, cake and
dancing after we had all gone to bed.
Miss Frances Jones + Miss Jones gave a
Hoodo, I mean a Hindoo dance (Great
applause.) After "I love her just the
same" (Fine tenor.) we sang some songs

Puddle Dock.

N. C. Wyeth (1882–1945)
In a Dream I Meet General Washington, 1930
Oil on canvas, 72 3/8 x 79"
Purchased with funds given in memory of
George T. Weymouth, 1991

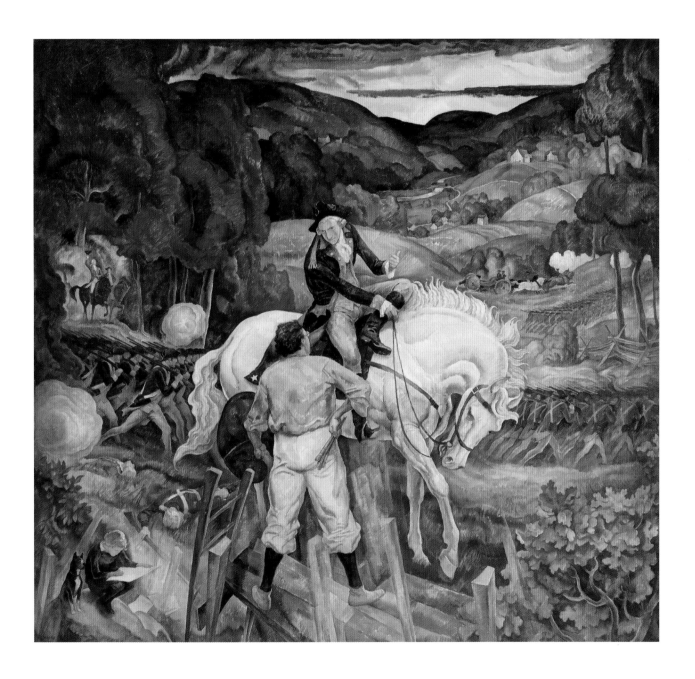

John Denys McCoy (b. 1938)
Film segment from *The Port*
(Port Clyde, Maine), ca. 1962.
Gift of John Denys McCoy. Walter and
Leonore Annenberg Research Center,
Brandywine River Museum of Art

N. C. Wyeth (1882–1945)
The Drowning, 1936
Oil on canvas, 42 x 48 $^1/_8$"
Bequest of Carolyn Wyeth, 1996

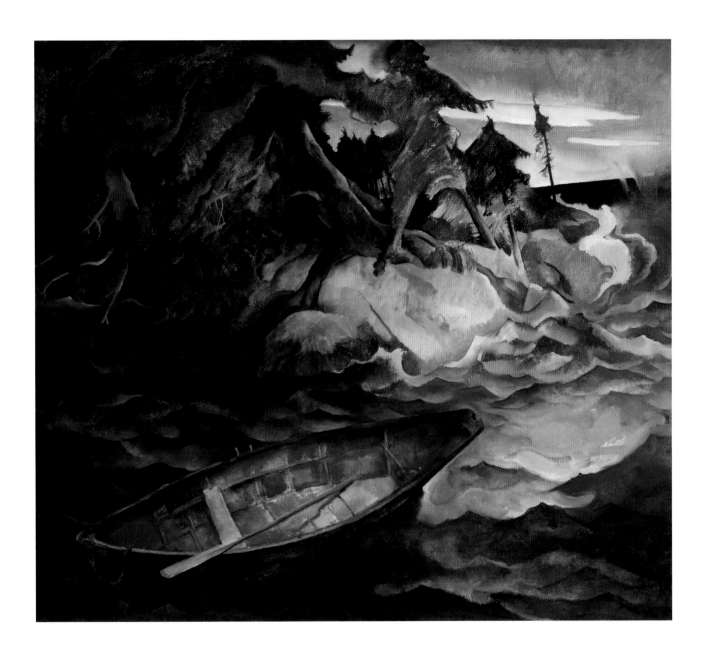

Andrew Wyeth (1917–2009)
Adam, 1963
Tempera on panel, 24 $1/4$ x 55 $1/8$"
Gift of Anson McC. Beard, Jr., 2002

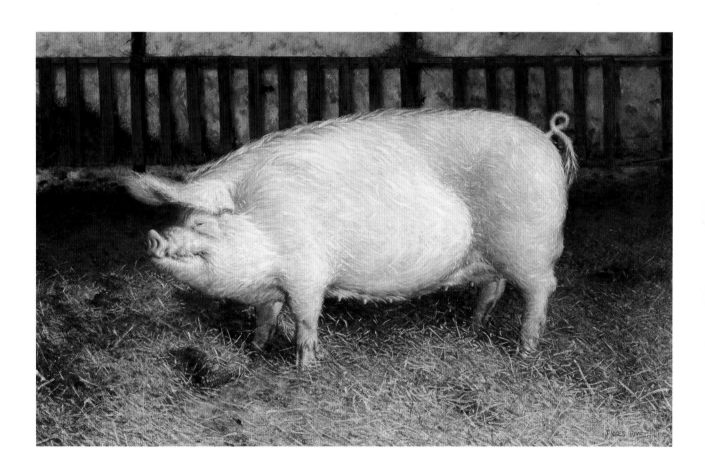

OPPOSITE
Jamie Wyeth (b. 1946)
Lime Bag, ca. 1964
Oil on panel, 16 x 12"
Gift of Mr. and Mrs. Andrew
Wyeth, 1970

ABOVE
Jamie Wyeth (b. 1946)
Portrait of Pig, 1970
Oil on canvas, 52 $^3/_8$ x 84 $^5/_8$"
Gift of Betsy James Wyeth, 1984

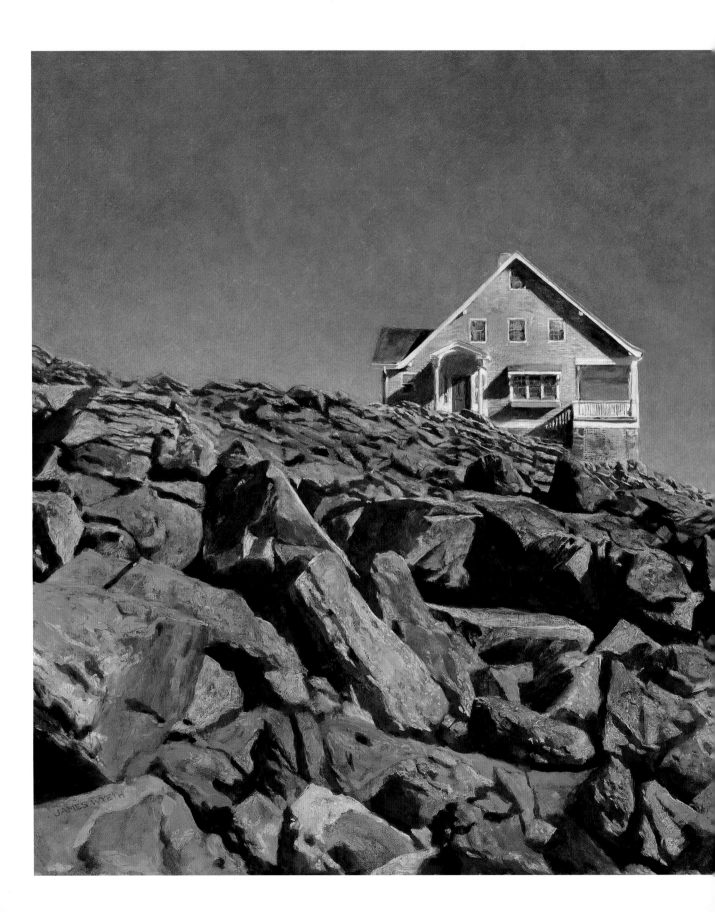

Jamie Wyeth (b. 1946)
Kent House, 1972
Oil on canvas, 30 x 40"
Gift of Mr. and Mrs. Andrew Wyeth, 1985

NEXT PAGES
Sunset at the Laurels Preserve,
landscape in southeastern Pennsylvania
safeguarded by the Brandywine
Conservancy

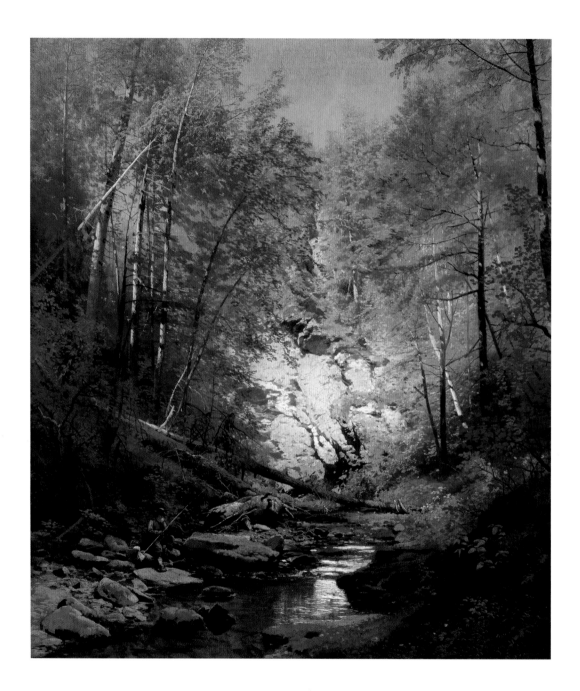

Herman Herzog (1831–1932)
The Sanctuary – Adams Brook,
ca. 1880
Oil on canvas mounted on board,
37 ¹/₈ x 33 ¹/₈"
Gift of Elizabeth and Raymond Forrest, 2016

James Welling (b. 1951)
Sycamore, 2010
Archival inkjet print on rag paper,
42 x 28"
Gift of Prince and Princess de Chimay, 2016

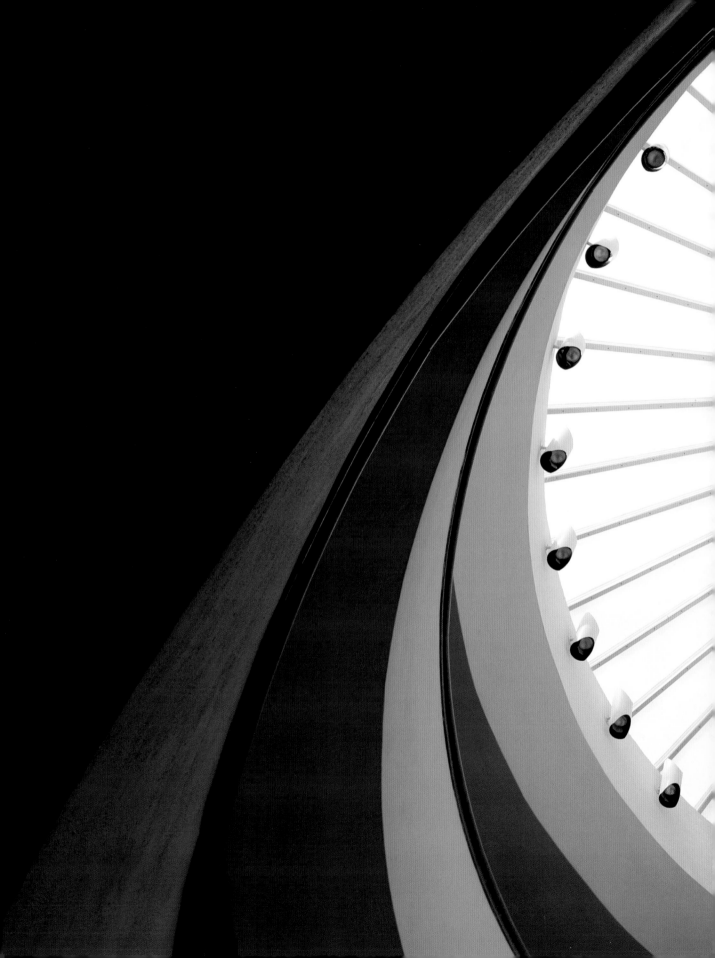

Frank E. Schoonover (1877-1972)
"White Fang's free nature flashed again, and he
sank his teeth into the moccasined foot," 1906
Oil on canvas, 35 $^3/_8$ x 19 $^5/_8$"
Illustration for "White Fang, Part III" by Jack
London, *The Outing Magazine,* July 1906
Gift of Mr. and Mrs. Andrew Wyeth, 1986

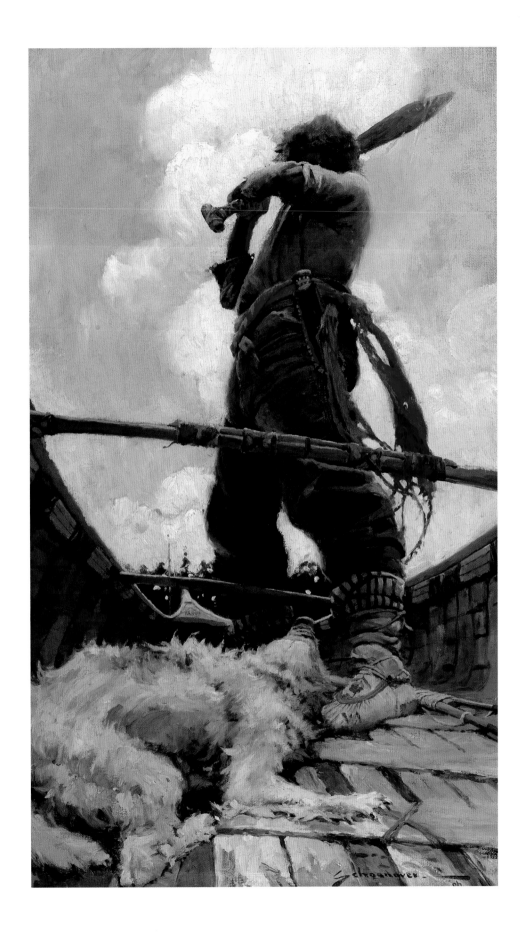

Alice Barber Stephens (1858–1932)
The Woman in Business, 1897
Oil on canvas, 25 x 18"
Illustration for "The American Woman"
by Alice Barber Stephens, *Ladies' Home Journal,* Sept. 1897
Acquisition made possible through
Ray and Beverly Sacks, 1982

HOLIDAYS AT THE BRANDYWINE

ABOVE

The Brandywine Railroad,
a tradition since 1972

OPPOSITE, TOP

A Brandywine "Critter," made by volunteers

OPPOSITE, BOTTOM

The Scaife Dollhouse, ca. 1900

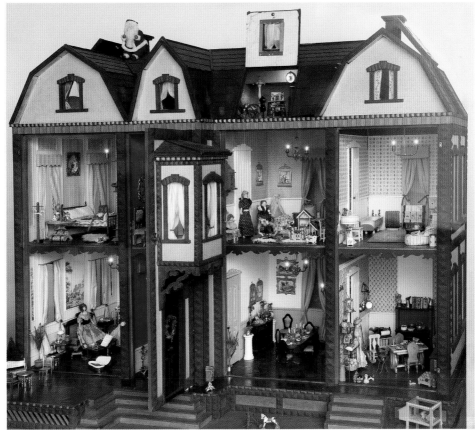

First published in the United States of America in 2017 by

Skira Rizzoli Publications, Inc.
300 Park Avenue South
New York, NY 10010
www.rizzoliusa.com

in association with

Brandywine River Museum of Art
1 Hoffmans Mill Road
U.S. Route 1, P.O. Box 141
Chadds Ford, PA 19317
www.brandywinemuseum.org

This publication is made possible through the generosity of Alan Slack.

Library of Congress Control Number: 2016961410

ISBN: 978-0-8478-5961-0 (hardcover)
ISBN: 978-0-8478-5962-7 (paperback)

For Skira Rizzoli Publications, Inc.:
Publisher: Charles Miers
Associate Publisher: Margaret Rennolds Chace
Editor: Ellen Cohen
Designer: Henk Van Assen, HvADesign, with Igor Korenfeld

Front cover: **N. C. Wyeth** (1882–1945), *The Drowning* (detail), 1936. Oil on canvas, 42 x 48 $^1/_8$". Bequest of Carolyn Wyeth, 1996

Back cover: **Guy Pène du Bois** (1884–1958), *The Appraisal* (detail), 1926, Oil on canvas, 38 x 28 $^1/_2$". Richard M. Scaife Bequest, 2015

Frontispiece: **Andrew Wyeth** (1917–2009), *Pennsylvania Landscape* (detail), 1941. Tempera on panel, 35 x 47". Bequest of Miss Remsen Yerkes, 1982

2017 2018 2019 2020 / 10 9 8 7 6 5 4 3 2 1

Printed in China

PHOTO CREDITS

Brandywine River Museum of Art object photography by Brilliant, Exton, PA; Rick Echelmeyer; Daniel Jackson

Works by James Welling: © James Welling, pp. 64–65, 127

Work by George A. Weymouth: 1974 © George A. Weymouth, p. 24

Works by Andrew Wyeth: © 2017 Andrew Wyeth / Artists Rights Society (ARS), New York: pp. 2, 29, 41, 118–119. © Brandywine River Museum of Art, p. 47

Works by Jamie Wyeth: © Jamie Wyeth, pp. 51, 53, 120, 121, 122–123

•••

Carlos Alejandro: pp. 21, 54, 56–57, 58, 59, 63 (bottom), 104–105, 134, 135 (top right)
Chuck Bowers: pp. 124–125
Brilliant, Exton, PA: pp. 48–49
Tom Crane: pp. 14–15
Rick Echelmeyer: pp. 63 (top left); 78–79, 92–93, 135 (bottom right)
Tamanya Garza: pp. 128–129
Charles George: pp. 66–67
Mark Gormel: pp. 84–85
Dan King: pp. 10–11
Peter Ralston: p. 61, courtesy Ralston Gallery, www.ralstongallery.com
Joshua Schnapf: pp. 20, 63 (top right), 65
Andrew Stewart: pp. 6–7, 22–23, 74–75